The Art of Infrared Photography

by Joseph Paduano

4th Edition

AMHERST MEDIA, INC. ■ BUFFALO, NEW YORK

For Johanna Ericson for her longtime friendship and untiring support.

Acknowledgements:
Much thanks to the gang at Dorn's Photo Shop (especially Bill Matlack); Andy, Jeannette, Jim and Kathy at Photo Unlimited; Jeanne Bley; Barbara Engel (hand-coloring expert); Natalie Houser; Jeff Parent, Tom Weber, Randy DeFrank, Robert Salmon and Jodie Belcher at Kodak; Phil Braden at Minolta; Carl Harris; Robyn Silk; and Amherst Media.

Copyright © 1998 by Joseph Paduano

Published by:
Amherst Media, Inc.
P.O. Box 586
Buffalo, NY 14226
Fax: 716-874-4508

Publisher: Craig Alesse
Senior Editor/Project Manager: Richard Lynch
Associate Editor: Frances J. Hagen
Assistant Editor: Emily Carden
Editorial Assistant: Amanda Egner

All photos by: Joseph Paduano
Handcoloring by: Barbara Engel

ISBN: 0-936262-50-8
Library of Congress Catalog Card Number: 97-075204

Printed in the United States of America
10 9 8 7 6 5 4 3 2 1

Notice of disclaimer: The information contained in this book is based on the author's experience and opinions. The author and publisher will not be held liable for the use or misuse of the information in this book.

Table of Contents

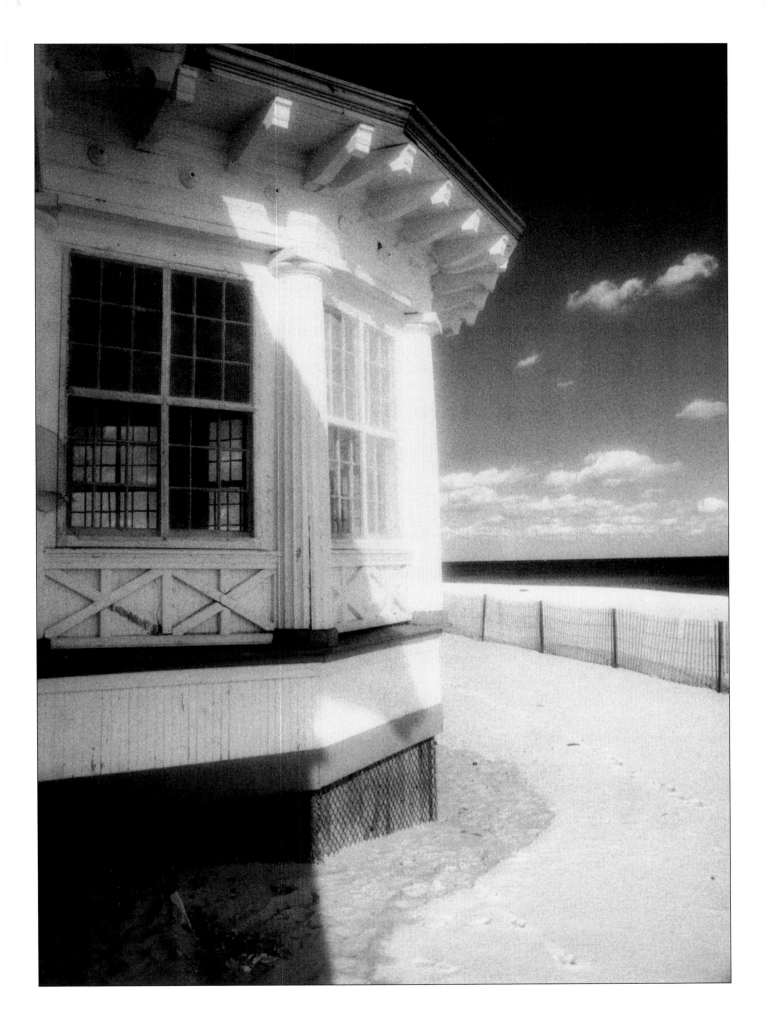

CHAPTER ONE
Infrared Theory

"...produce dream-like, dramatic images..."

If you feel confined by the limits of conventional film and want to expand the boundaries, then infrared photography is the answer. More and more photographers are discovering the thrill of producing dynamic infrared images.

B&W and color infrared films produce dream-like, dramatic images, although the techniques used to get results with infrared film have been somewhat unknown. This book reveals the truth behind the myths of infrared film.

With the information from the text and photographs, you can learn to create your own stunning infrared images. Infrared pictures capture the viewer's attention, making an emotional connection not always possible with conventional films.

B&W infrared film allows you to explore styles like the surreal, low-contrast ethereal and the high-contrast, day-for-night effect. Filters, lenses and controlled exposure and development can all work together to produce magical images — with color or B&W film.

If you have run out of ideas or need a change from the norm, infrared film is the next step in your photography. B&W and color infrared film can be the catalyst that enables you to photographically alter your view of the world. Learn to capture infrared images with a heightened awareness of contrast, drama, light, and color, limited only by your imagination.

Infrared photography is the technique of using a camera to record an image of a subject or scene that emits, reflects or transmits infrared radiation. The difference between infrared film and panchromatic films such as Kodak Plus-X, Tri-X and T-Max is that the emulsion of those films is sensitive only to ultraviolet and visible light — not infrared light.

To achieve a better understanding of infrared film, it helps to see where infrared radiation falls in the overall

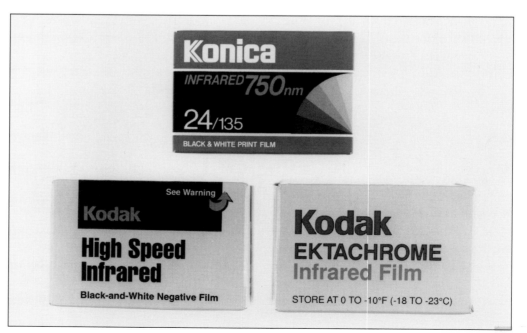

1-1: 35mm packages of Konica B&W infrared 750, Kodak High Speed B&W infrared, and Kodak Ektachrome color infrared film. Kodak High Speed infrared is also available in 4x5 (#4143) format. Konica Infrared 750 is also available in 120 format.

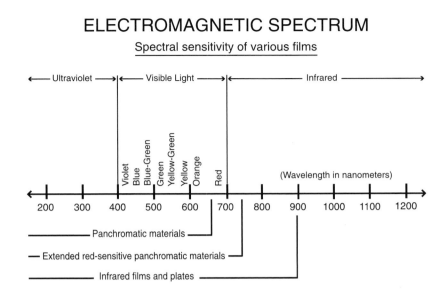

1-2: The electromagnetic spectrum showing the spectral sensitivity of various films.

electromagnetic spectrum. The spectrum is made up of wavelengths — measured in nanometers (nm; one billionth of a meter) — that grow longer as the spectrum moves from ultraviolet to infrared.

The visible spectrum is made up of wavelengths from about 400 nm at the blue end, to about 700 nm at the extreme red end.

In addition to visible light, invisible radiation exists at both ends of the visible spectrum. At one end of the spectrum are the relatively short ultraviolet (below violet) wavelengths that occur below 400 nm, and at the other end are the longer infrared (below red) wavelengths — beginning at about 700 nm and extending to 1200 nm in the near infrared range.

Most infrared sensitized films record infrared radiation from about 700 to 900 nm. To our eyes, ultraviolet and infrared wavelengths are invisible, because the human eye cannot see wavelengths below 400 or beyond 700 nm.

The range of radiation in the electromagnetic spectrum that film emulsions respond to is known as spectral sensitivity (see diagram 1-2).

Kodak infrared film contains spectral sensitivity from 700 to 900nm in the infrared range. Peak sensitivity is from 770 to 840nm. Konica has infrared spectral sensitivity from 640 to 820nm, peaking at 750nm.

Infrared film cannot actually record heat. The film is not sensitized to record the far infrared wavelengths that produce heat. It records infrared wavelengths produced by objects that may emit heat.

Foliage and Infrared

In a typical outdoor scene on a sunny day, green foliage and grass take on a white, snowy appearance (especially in late spring/early summer). The chlorophyll, leaf and blade cell structures in a healthy plant absorb visible light and reflect most of the infrared radiation to which the film is sensitive.

Pine, fir and spruce trees record less white than trees with large leaves, like maples or elms. Palm trees and succulents (such as cactus or yucca plant) record white because of a broad leaf surface.

In direct sunlight, portions of foliage and grass that are in the shade record in medium to dark gray tones rather than snowy. These shadow areas usually retain good detail.

The snowy look of grass and foliage is also reduced when the sky is overcast. More gray tones are recorded in grass and foliage, resulting in a softer image.

Note: Although grass and foliage record as white, man-made green objects usually record in dark tones. Green objects will absorb, rather than reflect, infrared rays.

"foliage and grass take on a white, snowy appearance."

Infrared film records unhealthy plant life as dark gray, not white. Autumn leaves, which still retain chlorophyll, will record in gray tones. (Leaf color is also a factor.)

Objects and Infrared

In direct sunlight, some buildings and light-colored objects appear luminous. Kodak infrared film records a "glow" or "halo" (halation) around the edges of these objects when a strong source of long wavelength radiation (sunlight) illuminates the object (see photo on page 45). The object then reflects or transmits the visible light as longer wavelength infrared radiation.

Snow, sand, clouds, and red objects also record in light tones (see photo on page 53). Water records either light or dark, depending on how the film records objects reflecting off the water's surface (see photo 1-3). Black objects absorb infrared radiation, reproducing as very dark or black.

A person's skin records as light gray with infrared film. Skin records very white when the subject is photographed in direct sunlight or with flash. Skin in shadow records dark because of low reflected infrared radiation where the sun doesn't reach the subject. With infrared film, dark hair and dark eyes appear dark. Light hair records in light or white tones, and light-colored eyes can look eerie. Lipstick must be deep purple or black to be seen.

With Kodak infrared, the "glow" or "halo" effect occasionally records around the outline of a person photographed in direct sunlight, especially if the person is wearing white or light-colored clothes.

Note: Many photographers prefer Kodak infrared over Konica to create ethereal, haunting images. The anti-halation coating on Konica's infrared film, as well as lower infrared sensitivity, reduces the film's ability to produce a luminescent

1-3: Water will photograph either light or dark depending on the objects that reflect off the surface.

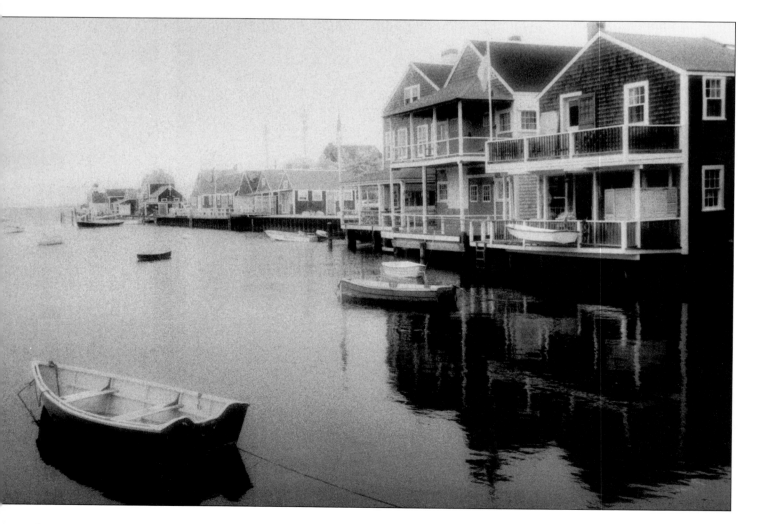

image when highly reflected objects are photographed. Kodak film does not have the anti-halation coating.

While dark clothing records dark and light clothing records light or white, some material that the eye interprets as dark records light with infrared film. Black satin and dark sheer material can record in light gray tones.

Light and Shadow

On a sunny day, a blue sky photographs dark because there is little infrared radiation present in sky not near the sun. Because clouds reflect a lot of infrared and record white, there is strong contrast between the sky and clouds on a sunny day. This produces dramatic, surreal effects (see photo on page 54).

Some high contrast daylight infrared photographs appear to have been taken at night, only illuminated by moonlight (see photo on page 78). The appearance of these images contributes to the misconception that infrared film can produce a properly exposed night photo under poor or extremely low light.

To shoot infrared at night, a time exposure must be made or you can illuminate the scene externally.

Shooting on a foggy, hazy or overcast day gives the sky a light appearance and reduces contrast. Shooting on a clear day while facing the sun records the sky as white.

When infrared film is exposed through a red filter, the scattering of haze-producing blue light is blocked. This haze-reducing quality allows details of a scene to be sharper (see photo 1-4).

Note: Because Konica infrared film does not usually record blue skies as deep black, the surreal look and moonlight effect are greatly diminished.

1-4: By penetrating the haze, infrared film reveals detailed information and produces excellent tonal range in the distant mountains. Kodak infrared film and a No. 25 red filter.

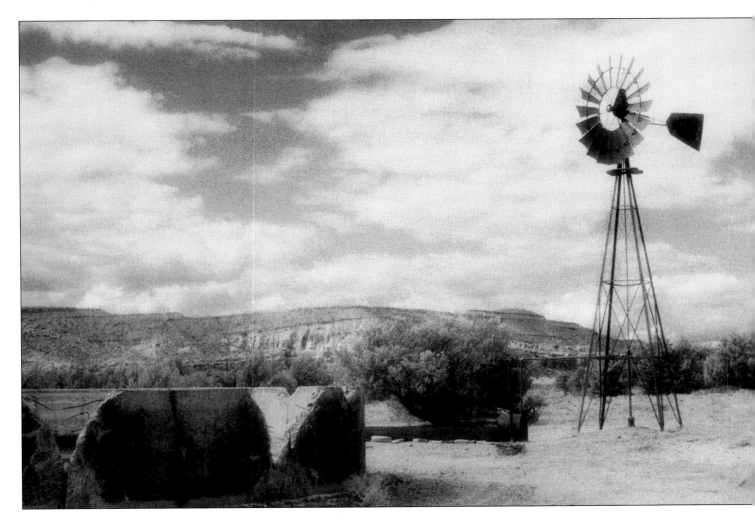

CHAPTER TWO
Precautions

"...prevent fogging or sensitivity loss..."

2-1: Warning label on the top of the plastic container of Kodak B&W infrared film.

Infrared films need special care to prevent fogging or sensitivity loss. Unprocessed film (exposed or unexposed) should be refrigerated at 55°F (13°C) or colder, in the original sealed container.

Keep the exposed film cool and dry, and you should process the film soon after exposure.

Before loading or processing film that has been in cold storage, you should remove it from the refrigerator about one hour before use and let it stand at room temperature. This eliminates moisture build-up on the film.

Loading and Unloading Film

Kodak B&W infrared film **must** be loaded and unloaded in total darkness or the film will fog (see photo 2-1).

Note: Konica infrared may be loaded and unloaded in subdued light without fogging. This is possible because the Konica film contains an anti-halation coating and lower sensitivity to infrared radiation.

Kodak infrared is properly loaded when the camera sprockets are aligned with the sprocket holes of the film. The film leader should also be secured on the take-up spool (see photo 2-2).

Close the back of the camera, and if equipped with a film rewind lever, rewind clockwise to put tension on the loaded film (see photo 2-3).

If shooting many rolls of Kodak infrared, an opaque changing bag is needed to load and unload film.

When working with infrared film in warm weather, keep exposed and unexposed film stored in the original containers, protected from heat and sunlight. Also, keep a loaded camera in a cool, shaded area.

Pressure Plate

If your camera contains a dimpled pressure plate, shoot a test roll to see if a problem arises. If a dotted pattern appears on the negatives, replace the dimpled plate with a smooth plate.

Otherwise, attach a piece of exposed, developed film to the dimpled plate with double-sided tape. This acts as a barrier and should eliminate imprinting of the dimple pattern on the film.

Infrared Sensor

Avoid camera models with an infrared sensor that counts the sprockets as part of the film transport mechanism: it may cause Kodak film to fog or streak.

These cameras include Canon EOS models, Elan, Elan II, Elan IIE, A2 and A2E; the Rebel X, XS and G; Minolta Maxxum 300 si and 400 si.

Imprinting

The pressure plate on the Minolta Maxxum (among others) has a cut-out for imprinting the date and time that leaves a phantom imprint on an infrared negative.

Replace this plate for B&W infrared film, or apply silver mylar photographer's tape to the back side of the plate over the holes.

Darkroom and Travel

Fluorescent lights in the darkroom may cause film fogging. Wait 3 or 4 minutes after turning off the lights before loading, unloading or processing film. This allows phosphorescence produced

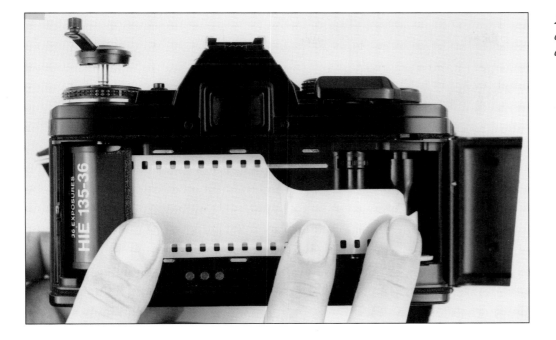

2-2: When loading in the dark, feel for the sprockets and take up spool.

2-3: Turn the film rewind lever clockwise to put tension on the film after it is loaded. If the film is loaded correctly, the tension will cause the rewind lever to move when the advance lever is turned.

by the lights to subside and avoids film damage.

Use a lead laminated film shield bag when traveling to protect infrared film from x-ray damage from airport security devices. Film shield bags can be purchased from your camera dealer.

Note: Not all camera or photo dealers carry B&W infrared film. Check with your photo dealer to see if the store stocks it. If not, ask the dealer to order it for you. The store should keep film refrigerated before you purchase it.

Konica infrared film is more difficult to locate than Kodak infrared. It will probably have to be special ordered through your photo dealer — and there may be a minimum amount of film that must be purchased. You might get the film through mail order photo companies, where there is greater availability and usually no minimum purchase.

CHAPTER THREE

Filters & Focusing

"Use filters to achieve optimum results..."

Use filters to achieve optimum results with infrared film. Without an orange, red or infrared filter to absorb unwanted visible and ultraviolet light, infrared images appear flat and have low contrast. Grass and foliage record in gray tones rather than white, and a blue sky reproduces as light gray or white instead of dark gray or black.

Orange, red and infrared filters absorb ultraviolet, violet and blue light. The redder the filter, the more visible light the filter absorbs: blue/green, yellow, orange. Opaque infrared filters which absorb visible light allow only the longer (infrared) wavelengths to reach the film.

Red Filter

Use a No. 25 red filter (Cokin® equivalent No. 003) with Kodak infrared film. It increases contrast and achieves the classic "infrared look" of dark skies and white vegetation. Red objects record as white because these transmit longer red wavelengths which the filter allows to pass.

The red filter allows infrared film to penetrate through haze because: longer wavelength infrared rays are not scattered as much as visible light; objects at ground level stand out by reflecting more infrared wavelengths than visible light; and the brightness ratio between objects and the atmosphere is greater in infrared than in visible light, increasing subject detail.

Orange Filter

The No. 16 orange filter (Cokin® equivalent No. 002) with Kodak infrared film blocks ultraviolet and most unwanted visible light and allows transmission of red, blue/green and infrared wavelengths. More shadow and highlight detail is possible, but contrast is reduced.

With Konica infrared, the snowy white "infrared look" of vegetation is less pronounced than with Kodak. Red and orange filters are interchangeable when using Konica film, which is blind to blue/green light, so a red filter is not always necessary to get good contrast.

Exposure Compensation and Filter Factor

Since filters decrease the amount of light that reaches the film, exposure must be increased to make up for the light lost. This "exposure compensation" is measured in f-stops. The lens can be opened wider to adjust for the filter ("filter factor"). Exposure is compensated by the amount indicated by the filter factor.

Filters for Infrared	Filter Factor	Exposure Compensation
No. 16 Orange	3	1 1/2 f-stops
No. 25 Red	4/6	2-2 1/2 f-stops
No. 29 Deep Red	8	3 f-stops
Infrared	8/32	3-5 f-stops (manual compensation required)

3-1: Chart of filters, filter factors and exposure compensations.

Based on the 2:1 concept, a filter factor of 4 requires a 2 stop increase in exposure, and a filter factor of 8 requires a 3 stop increase in exposure. Filters, filter factors and exposure compensation for infrared films are listed in chart 3-1.

Note: Most cameras meter through the filter and will automatically compensate for the filtered exposure. Manual compensation is required in the manual mode or with a hand-held light meter.

The red filter removes all other color from the scene you view through the lens.

This "screening" out of color reveals the basic contrast and indicates how the infrared print will look. Filters made specifically for infrared films produce dramatic contrast and tonal effects. These opaque infrared filters are best suited for architectural, landscape or still life photography.

- No. 88A filter absorbs wavelengths up to 710 nm and transmits infrared starting at 730 nm.
- No. 89B absorbs light up to 700 nm and transmits infrared starting just beyond 700 nm.

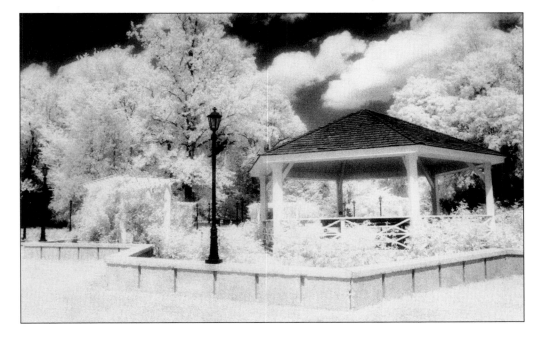

3-2a and b: Both of these photos were shot with Kodak infrared film. The top photo was exposed using a No. 25 red filter; the bottom photo, a No. 87 infrared filter.

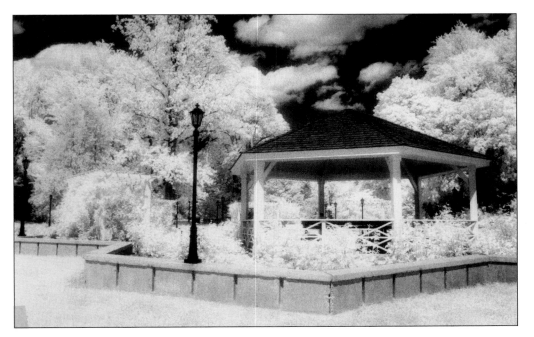

3-3a and b: Compare these two photos. The top photo was taken with Konica infrared film. The bottom photo was taken with Kodak infrared film.

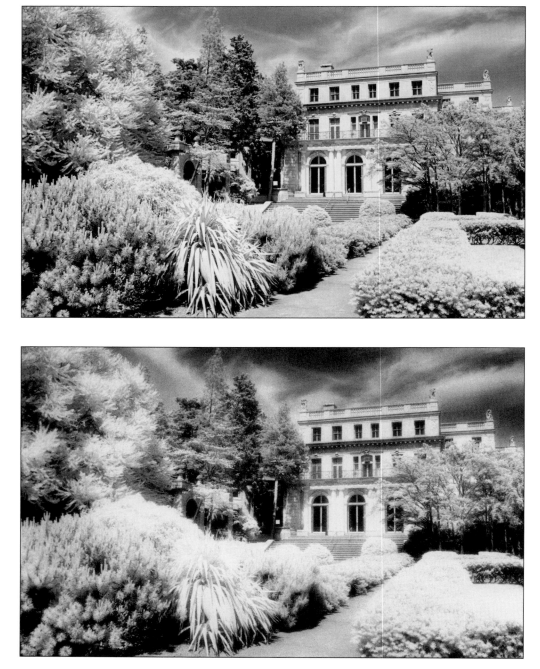

• No. 87 filter absorbs wavelengths up to 730 nm and transmits infrared at around 760 nm.
• No. 87C absorbs wavelengths up to 780 nm and transmits infrared starting just beyond 820 nm.

A No. 29 deep red filter (with Kodak infrared) is more practical than an infrared filter, producing similar results. It allows the transmission of visible light, which permits viewing and metering through the lens.

An infrared filter used with Konica infrared increases contrast over the No. 16 orange, No. 25 or No. 29 red filters. An infrared filter helps the film achieve optimum infrared effects of dark skies and white vegetation.

But the more infrared sensitive Kodak film produces very dramatic effects with the No. 25 red filter. This allows viewing through the lens and only cuts out 2 to 2 1/2 stops of light.

Note: Do not use the No. 87C infrared filter with Konica infrared: it transmits wavelengths beyond the film's infrared sensitivity.

Helpful Hint: Because the infrared film is sensitive mostly to infrared light, the addition of a polarizing filter, which polarizes visible light, is not necessary.

Focusing

Because infrared film focuses infrared rays differently than it focuses visible light, you need to make adjustments when focusing.

Focus visually as you normally would, note the focal distance setting, and shift the focusing ring so the focal distance lines up with the infrared focusing mark on the lens barrel. (For cameras with autofocus systems, set the camera to the manual focus mode.)

On manual focus lenses, this mark is usually a red dot, red line or "R" found on either side of the focus indicator line. The scene or subject being photographed will look slightly out of focus through the viewfinder, but will record in focus on the film.

Examine photo 3-4. The lens on the left is a fixed focal length lens with a red "R" as the infrared focusing mark. The one on the right is a zoom lens. The focusing marks are vertical red lines on the lens. The various lenses in the zoom are indicated below each line.

On most autofocus lenses, the infrared focusing mark is a white or red dot. On manual focus zoom lenses with a single sliding zoom/focus collar, the infrared focusing mark is usually a red line. Slide the zoom/focus collar to the desired lens in the zoom, focus visually, then turn it until the visual distance setting is even with the red line.

To adjust focus for infrared film (using a zoom with a two-ring system), note the distance at which you are visually focused. Then, depending on the lens used in the zoom, shift the focusing ring to the infrared focusing mark indicated with the millimeter number of that lens.

If using a lens that does not contain an infrared focusing mark, adjust by focusing a few feet in front of the scene.

On 4 x 5 view cameras where there is no focusing mark for infrared, extend the bellows by 1/4 of 1% of the focal length of the lens. Focus adjustments are unnecessary if the lens is stopped down to f/32 or higher.

"...you need to make adjustments when focusing."

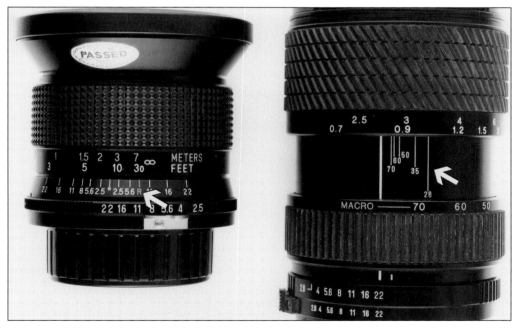

3-4: After visual focusing, move the focusing ring of the lens so the distance setting is lined up with the infrared focusing mark.

Film Speed & Image Grain

"Slow films are less sensitive to light."

Each type of film has a recommended speed or rating number. For years, the number was called ASA or American Standards Association. Now the rating number is called ISO or International Standards Organization.

Slow films are less sensitive to light. Fast, high speed film is more sensitive to light and requires less exposure than the slow film. Infrared films are given only a suggested film speed rating because exposure meters cannot be relied on to produce correct exposures with infrared.

- With no filter, Kodak infrared has a suggested ISO/ASA of 80 for daylight. Konica suggests an ISO/ASA of 32.
- With a No. 25 red filter the film speed for Kodak is the equivalent of ISO/ASA 20. Konica is ISO/ASA 8.
- A filtered ISO/ASA of 20 for Kodak is acceptable, especially in bright light. Under low light, however, use moderate shutter speeds and medium to large apertures.
- A filtered ISO/ASA of 8 for Konica requires a tripod and slow shutter speeds. If there is enough light to hand-hold the camera, large apertures and slower shutter speeds are necessary. So, it is more practical to use a higher ISO/ASA setting for both films.

Konica is a slower film than the high speed Kodak film and usually requires larger apertures and/or slower shutter.

Establishing the ISO/ASA numbers a film performs best at is known as the exposure index, or EI. I find EI 200 (Kodak) and EI 50-64 (Konica) work best, with an exposure error margin of ±1 stop.

Of course, film speeds for infrared are variable.

Note: Under low light conditions, use an ISO/ASA of 100 for Konica.

Addition of a Filter

Once a film speed is chosen and set on the camera, the addition of a filter effectively reduces film speed even though the speed setting remains unchanged. Because the filter decreases the amount of light that reaches the film, the exposure meter's sensitivity to light is affected.

If you set a film speed of ISO/ASA 200 on the camera, add a No. 25 red filter and compensate exposure for the filter, the film speed will be the equivalent of ISO/ASA 50.

"Pushing" and "Pulling" Film

Rating the films at speeds other than those established, especially if exposures are not bracketed, requires adjustment of development times.

This "pushing" or "pulling" the film changes the way the film is developed, not the actual speed of the film.

Push film (for added speed) when there is not enough available light to get acceptable exposure readings. This lets you use smaller apertures for increased image sharpness and depth of field, and faster shutter speeds (at wider apertures) to stop motion and minimize camera shake. Increase development time to compensate for underexposure.

Pull film to reduce speed when a lot of undesirable light is present. Reduce development time to compensate for overexposure. Pushing causes higher film contrast and a loss in shadow detail.

When pushing film, increase development time by 20% for each 1 stop increase in film speed. For pulling, decrease 20%. Pulling reduces film contrast, and shadow areas retain detail.

Bracketing Exposures

Once the film speed is set, bracketing exposures effectively changes film speed without making adjustments to development time. Although more film is used when bracketing, it ensures that the negatives will be correctly exposed.

For each 1 stop increase (opening of the lens), the film speed is halved. (If f/16=ISO/ASA 200, then f/11=100.)

For each 1 stop decrease (closing of the lens), the film speed is doubled. (If f/8=ISO/ASA 50, then f/11=100.)

Bracketing exposures by adjusting shutter speed lets a selected f-stop setting remain constant.

Note: If your camera has a system that reads the DX coding information and automatically sets the ISO/ASA, this system does not work with infrared. The ISO/ASA has to be set manually.

If there is no manual override, most cameras select ISO/ASA 100. To get ISO/ASA of 200 (for Kodak), decrease exposure by 1 stop.

Image Grain

Infrared films contain "grain": tiny bits of silver halide, a light-sensitive material used on film emulsion and photographic paper.

High speed films contain large, coarse grain while slow films contain small, tightly packed grain. Because Kodak infrared is a high speed film, it produces more obvious grain than Konica.

Note: Because Konica infrared film is slower, the focused subject will be sharper

4-1: Infrared film creates atmosphere through its softness and grain.

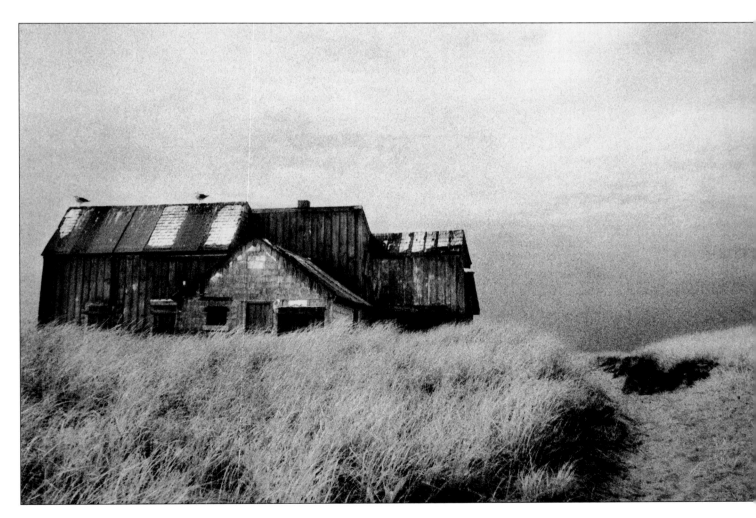

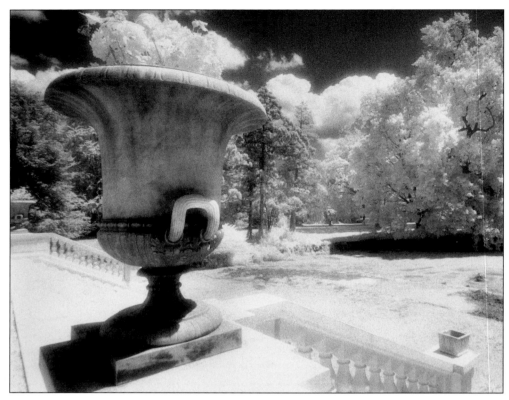

4-2a and b: The same outdoor scene shot under the same lighting conditions. One negative was exposed correctly, the other was overexposed. The print made from the correctly exposed negative (above) is more dramatic. The low contrast print made from the overexposed negative (below) is softer with less detail, achieving a dream-like appearance. This is due to the larger grain size overall and the lighter tone in the shadow areas.

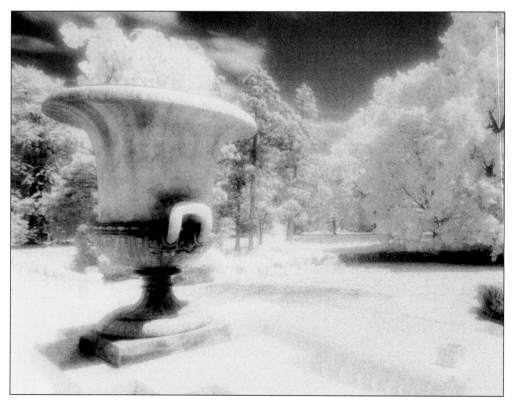

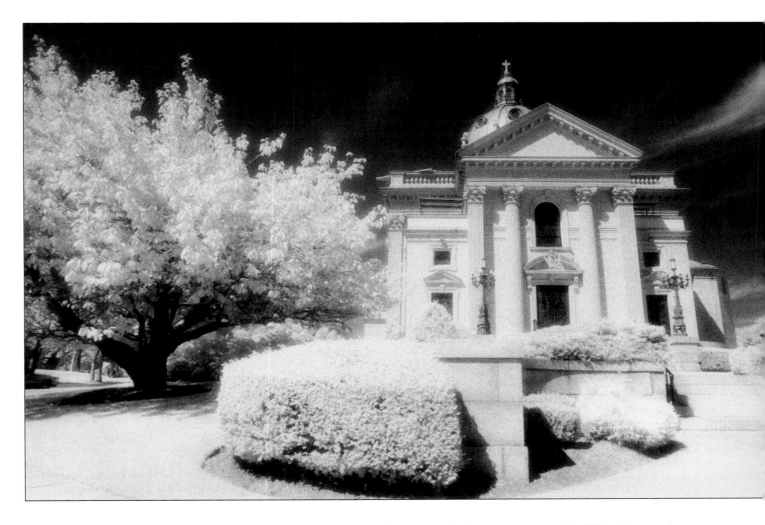

than the Kodak image. One way to control the appearance of film grain is through the use of a specific negative developer to increase or reduce negative contrast. Otherwise adjust exposure or development of the negative (or both).

Overexposure accentuates the appearance of the grain, and underexposure reduces its coarse appearance. The overexposed image appears soft and dream-like; the underexposed image is stark and has dramatic contrast.

With infrared film, the difference between scenes photographed under different lighting conditions is pronounced. A scene shot on a sunny day produces a dynamic, high-contrast, medium grain image.

The same scene photographed on a hazy day produces an image with distinctive grain, low contrast and a soft, evocative look.

Film tests that have established an EI of 200 for Kodak 35mm infrared also work for Kodak 4 x 5 infrared. And the EI's for Konica 35mm infrared also work for 120 Konica infrared.

Slight overexposure of these larger size negatives produces an image with higher contrast, more detail and smaller grain size than an overexposed 35mm negative.

4-3: This photo, taken with Kodak infrared film, has less grain and higher contrast.

CHAPTER FIVE
Exposures

"The first roll of infrared film...should be a test roll..."

The first roll of infrared film you shoot should be a test roll to determine how accurate your exposure meter is for infrared exposures. Shoot a test roll at the established film speed using through the lens (TTL) metering. With the orange or red filter in place, bracket heavily from the meter readings for a given situation.

For maximum image sharpness, use a shutter speed that allows exposures with medium to small apertures, ideally in the f/8 through f/22 range. Keep a log of f-stops and shutter speed settings used for each shot. After developing the negatives, make a contact sheet and from the sheet, decide on which exposure adjustments to make for infrared film in your camera.

Note: Since Kodak infrared film tends to overexpose, make multiple exposures by stopping the lens down from the metered reading.

On a sunny day, basic exposure for Kodak high speed infrared film with a No. 25 red filter (rated ISO/ASA 200) is approximately 1/60 second at f/16. For Konica infrared, under the same lighting conditions and filter (rated at ISO/ASA 50), exposure is 1/60 second at f/11. (See table 5-1)

Infrared reflectance is generally greater at midday when the sun is higher in the sky. In late spring/early summer, infrared reflectance is high because of warmer temperatures and infrared radiation reflected from chlorophyll in vegetation.

When photographing with Kodak infrared film on a sunny day, meter the brightest area of the scene, other than the sky. From the reading, make multiple exposures to avoid overexposure when shooting white or light-colored buildings, sand, snow, grass and foliage. On an overcast day, meter from the overall available light and bracket.

Also make multiple exposures with Konica infrared because the film has a tendency to underexpose in bright sunlight. To increase density and contrast, and achieve the snowy white appearance with grass, foliage and light colored objects, overexpose the film by about 1 stop.

Exposure and Filters

When shooting with visually opaque infrared filters, meter through the lens without the filter. Focus visually and adjust the focus to the infrared focusing mark, compose the shot, then place the filter on the lens to make the exposure. Adjust the f-stop for the filter by opening the lens from 3 to 5 stops, based on the non-filtered meter reading.

Infrared filters compromise the use of small apertures to produce a sharp image, especially when hand-holding the camera.

When initially using infrared filters, shoot a test roll of film using the exposure compensation adjustments noted and bracket the exposures.

Shoot under various outdoor lighting conditions, and keep a log of correct adjustments to produce accurate exposures

If using a hand-held light meter and non-infrared filters over the meter cell, exposure compensation for the filter will be adjusted by the meter. This directly determines the filtered exposure and indicates the correct f-stop setting for the lens.

Infrared Indoors

Indoor photographs with a moody and haunting atmosphere can be created by shooting without flash on a sunny day.

Use daylight entering from windows or open doors as the primary light source, or combine the natural light with available indoor artificial light (see photos on pages 41 and 42).

If metering without the filter (in the manual exposure mode), make the exposure compensation when the filter is placed back on the lens. Mount the camera on a tripod and make multiple exposures by metering and exposing for the lightest area, darkest area, and an area in between.

Infrared film can be exposed indoors, without a flash, using existing tungsten or fluorescent light. Filters are unnecessary because infrared film is very sensitive to tungsten light.

For studio lighting, infrared film's heightened sensitivity to tungsten light is an asset when using photoflood or quartz-halogen lamps: these lights are the most efficient sources of infrared radiation.

When using fluorescent light to illuminate a subject, use a red or orange filter to absorb the increased blue light. Use of slow shutter speeds will allow small apertures for image sharpness. Incorporating either of these light sources into the composition with Kodak infrared usually creates a halo around the light source — a magical, enigmatic quality.

The best method of exposure is to make time exposures with filtration and a tripod-mounted camera. Time exposures permit the use of medium to small apertures. Make the exposures in 2 second increments up to 8 seconds after an initial exposure of 1 second.

"...a magical, enigmatic quality."

Suggested Trial Exposure for **Kodak High Speed Infrared Film** (35mm and 4x5).
Approximate outdoor exposures with No. 25 Red Filter ISO/ASA 200.

Direct sunlight	1/60	f/16
Hazy	1/30	f/16
Light cloud cover	1/30	f/11
Moderate rain	1/15	f/8

Suggested Trial Exposure for **Konica Infrared Film 750** (35mm and 120).
Approximate outdoor exposures with No. 25 Red Filter ISO/ASA 50*.

Direct sunlight	1/60	f/11
Hazy	1/30	f/8
Light cloud cover	1/30	f/5.6
Moderate rain	1/15	f/4

*If rating the film at ISO/ASA 64, exposures will be decreased by 1/2 stop from the f-stops listed. Rating the film at ISO/ASA 100 will decrease exposures by 1 stop.

Note: When using a No. 16 orange filter with Kodak or Konica infrared, the lens aperture will be closed down about 1/2 to 1 stop from the f-stop settings listed in this Table.

5-1: Trial exposures for Kodak and Konica Infrared Film.

CHAPTER SIX
Night & Flash Photography

"Existing outdoor light can be recorded at night..."

It is a common misconception that infrared film can "see" through darkness at night using daylight f-stop and shutter settings with no external illumination.

Existing outdoor light can be recorded at night using a tripod-mounted camera and slow shutter speeds. The background of the scene will be black, but the existing light will record as ghostly white light. With Kodak infrared, the halo effect will be very evident around strong light sources (see photos on page 65).

If there is not enough night light to get a meter reading (with a red filter), an f-stop opening of f/4 or f/2 using shutter speeds of 1/15 through 1/2 second will usually produce an acceptable negative.

Time exposures using apertures of f/5.6 or f/8, depending on duration, can be made shooting 2 second increments from 2 to 10 seconds. Make notes of exposure times and aperture settings for best results.

Electronic Flash

Infrared photographs can also be made outdoors at night or indoors using an electronic flash unit. The light output of the flash reflects back from the subject as a pleasing white light. You can use a red, orange or infrared gel over the flash head or lens, or use an infrared flash unit.

Using a filter or gel over the flash head will make it easier to see through the unfiltered lens in low light.

Flash exposures can be made using either the camera's manual, program (TTL flash only) or auto exposure modes. To make exposures in the manual or auto mode, use the guide number to calculate exposure. The correct shutter speed for flash exposures is usually 1/60 or 1/125 sec. To determine the proper f-stop setting, divide the guide number by the flash-to-subject distance. For example, a flash with a guide number of 160 for

Indoor Electronic Flash Guide for **Kodak High Speed Infrared Film**. with a No. 25 Red Filter (IS0/ASA 200)*.

Flash-to-Subject Distance (in feet)	f-stop	Shutter Speed	Flash and Camera Setting
5	f/11	1/60	Manual
10	f/5.6	1/60	Manual
15	f/4	1/60	Manual
20	f/2.8	1/60	Manual

*Based on use with a Sunpak BZ 2600 unit.

Note: The exposure compensation of a two-stop increase for the No. 25 red filter has already been adjusted for in this Table.

6-1: Trial exposures for Kodak Infrared Film.

ISO/ASA 200 speed film and a subject at 10 feet away has an exposure of f/16 (160 divided by 10).

Note: The flash guide number for each unit is already incorporated into the distance/f-stop scale found on the flash unit. Once you find the correct f-stop for the exposure (using a non-TTL flash), manual exposure compensation is required with any filter (see table 6-1). Aperture is selected based on flash-to-subject distance.

Flash photos can also be exposed automatically, through the colored filter over the lens or with a colored gel over the flash head — with a TTL dedicated auto flash unit in the auto or program mode.(See photo on page 55. This image illustrates a flash shot using a red gel over the flash head.) Exposure compensation for filtration is not required because the camera will automatically compensate.

Only use the program or auto exposure mode if the flash-to-subject distance is within flash range (5 to 20 feet with a red filter). If the subject is beyond flash range, even the largest aperture may not allow enough light to produce a properly exposed negative.

Flash Exposures

Bracket flash exposures if the flash-to-subject distance is close enough for use of an aperture other than the maximum. When bracketing (which allows greater exposure control), a non-TTL flash must be used. For flash exposures using infrared filters, or gels, do not use TTL flash. Exposure compensation is between 3 and 3 1/2 stops.

Avoid using an infrared flash or infrared filters/gels if the flash-to-subject distance is beyond 10 feet, unless pushing the (Kodak) film higher than ISO/ASA 200: exposure compensation may not otherwise be possible. Pushing the film to ISO/ASA 400 allows the use of an aperture large enough to produce a correct exposure and still maintain medium depth of field for acceptable image sharpness.

Konica infrared film is difficult to expose correctly when using a flash as the primary light source, unless positioned close to the subject (from 1 to 10 feet). Pushing the film to ISO/ASA 100 will usually permit use of flash if using a No. 16 orange filter or gel. Exposure compensation is then 1 1/2 stops, although you should increase exposure an additional 1 stop for the slower Konica film.

For flash exposures with Konica infrared (rated at ISO/ASA 100) using an orange filter or gel, use the flash guide (see table 6-1) for Kodak infrared. Find the appropriate flash-to-subject distance, locate the corresponding f-stop setting and open the lens an additional 1 stop.

You will need to use the manual exposure setting to adjust for filter exposure compensation and the additional exposure increase required for Konica infrared film.

When using flash outdoors at night, open the lens an additional 1 or 2 f-stops from indoor flash settings. For best results, use manual flash and camera settings and make test shots at a fixed distance (about 10 feet) from the subject, at several different f-stops.

A flash unit can be used when making outdoor daylight photographs to reduce contrast by illuminating the shadow areas of an exposure.

Mixing electronic flash with available sunlight is known as flash fill, and is especially useful when photographing a back-lighted or shaded subject.

To use flash fill, first determine the f-stop required for the correct daylight exposure using the proper shutter speed for an electronic flash, and set the camera for this exposure. Adjust the lens to an f-stop setting one stop smaller than the correct setting.

Note: When using flash fill with infrared film, use the filter over the lens method, not the colored or infrared gel over the flash head (or an infrared flash) to provide adequate fill light.

To determine the proper flash exposure for your flash unit, shoot a test roll and bracket the exposures. This will allow you to become familiar with the film and the results that can be achieved.

"Mixing electronic flash with available sunlight is known as flash fill..."

CHAPTER SEVEN

Processing & Printing

"...process the film promptly."

Once infrared film has been exposed, you should process the film promptly. Kodak and Konica do not process B&W infrared film.

If you do not process your own film, take the film to a photo lab (in the original sealed container) that processes B&W.

Always inform the lab that the film is B&W infrared (with Kodak). Konica infrared, however, would not be affected if accidentally exposed to light.

Note: Cameras with auto-rewind will leave the film leader (tail) protruding from the canister after rewinding the film.

If the film is accidentally exposed to light, the leader can transport light onto the exposed film in the canister (known as light piping). This can fog the first few frames or more of the film. To avoid this with Kodak infrared, manually rewind the film into the canister in total darkness.

Developers

Kodak infrared film can be processed in D-76, D-19, T-Max or HC-110 developer.

- To accentuate the grain and increase contrast of the negatives, you can use Kodak D-19, HC-110 (dilution B) or AGFA Rodinal developer.

- To produce negatives with less obvious grain and medium contrast, you can use Kodak D-76 or T-Max developer.

- To produce negatives with finer grain and increased contrast, you can use Kodak XTOL developer (1:1 dilution).

Konica infrared film can be processed in Kodak D-76 or DK-20 developer, or in Konicadol DP, fine or super developer.

- To emphasize the grain and increase contrast of Konica negatives, you can use Konicadol DP, Konicadol super or AGFA Rodinal.

- To produce fine grain appearance and medium contrast, you can use Konicadol fine, Kodak D-76 or DK-20.

- For a fine grain appearance and to increased contrast, you can use the Kodak XTOL developer (1:1 dilution).

When developing Kodak infrared, agitate for five seconds at thirty second intervals.

With Konica infrared, agitate continuously for the first minute and then for five

Suggested Trial Exposure for **Ilford SFX 200 Film** and **AGFAPAN APX 200S** at ISO/ASA 200. Approximate outdoor exposures with No. 29 Deep Red Filter.

Direct sunlight	1/60	f/11
Hazy	1/30	f/11
Light cloud cover	1/30	f/8
Moderate rain	1/15	f/5.6

7-1: Trial exposures for Ilford Special Effects and AGFAPAN APX 200S Infrared Film.

Processing Times for **Ilford SFX 200** at ISO/ASA 200. Approximate developing time in minutes. Small or large tank agitation: continuous for the first 10 seconds, then 10 seconds every minute.

Developer	Dilution	68°F (20°C)	75 °F (24°C)
Ilford ID-11	Stock	10	7
Ilford Microphen	Stock	8 1/2	6 1/2
Ilford Perceptol	Stock	14 1/2	10 1/2
Ilford Ilfotec HC	1:31	9	6
Ilford Ilfotec LC 29	1:19	9	5 1/2
Kodak D-76	Stock	10	7
Kodak T-Max	1:4	8 1/2	6 1/2
Kodak XTOL	1:1	10	8 1/4
Kodak HC-110	B	9	7 1/2
AGFA Rodinal	1:25	5	3 1/2

7-2: Processing times for Ilford SFX 200 film.

seconds at one minute intervals until the development procedure is finished.

Temperatures for developers range between 65° to 75°F (18° to 24°C). Avoid using development times of less than five minutes. This will result in poor uniformity. (See tables 7-4 and 7-5.)

Generally, stop bath and fixer should be the same temperature as the developer with these processing times: stop bath — 30 seconds with constant agitation; rapid fixer — 2 to 4 minutes with frequent agitation. Wash negatives for 20 to 30 minutes. A wetting agent such as Kodak Photo-Flo solution will minimize drying marks.

Finally, dry film in a well-ventilated and dust-free area. Always handle infrared negatives carefully: they're thin and tend to curl easily.

Grass, foliage, sand, snow and illuminated objects record especially dark on the negative.

Also, the edge of each frame on the negative strip will occasionally record flare (with Kodak infrared film) when sunlight or a strong light source produces high illumination. This is normal (and not a light leak).

Special Effects Film

Ilford Photo offers what they call a "special effects" film, sensitive to the very near infrared range. SFX 200 film has peak red sensitivity at 720 nm and extended red sensitivity up to 740 nm.

It is a medium speed film with distinctive grain, good haze penetration and no halation. Rated at ISO/ASA 200, the manufacturer says the film produces images with infrared-type effects. You can load the film in subdued light, and focus adjustments are unnecessary.

Filters that can be used with SFX 200 include a No. 12 yellow, No. 16 orange, No. 25 red, No. 29 deep red, 88A and No. 89B (No. 29, 88A and 88B give maximum effect). With these filters, the film will render blue skies slightly darker, and vegetation and skin tones slightly lighter than with panchromatic film. (See table 7-1 for exposure information.)

Do not use an infrared flash unit with the Ilford film. However, flash exposures can be made using colored filters or gels. Follow the instructions for flash exposures (see table 6-1, page 22), but open up 1 additional stop if using a No. 29 red filter. (See table 7-2 for processing information.)

AGFA Photo also makes an ISO/ASA 200 speed panchromatic B&W film that has extended red sensitivity into the near infrared range. AGFAPAN APX 200S has peak red sensitivity at 720 nm and extended red sensitivity up to 775 nm.

"Do not use an infrared flash unit with Ilford film."

Processing Times for **AGFAPAN APX 200S** at ISO/ASA 200. Approximate developing time in minutes. Small or large tank agitation: continuous for the first 10 seconds, then 10 seconds every minute.

Developer	Dilution	68°F (20°C)	75 °F (24°C)
AGFA Atomal	Stock	10	8
AGFA Refinal	Stock	6	4
AGFA Rodinal	1:25	5	3 1/2
Kodak HC-110	B	9	7 1/2
Kodak XTOL	1:1	10	8 1/4
Kodak D-76	Stock	10	7

Stop, fix, wash and dry negatives in the conventional manner.

Note: There are also several infrared films manufactured by NiiKhimfoto Proekt in Moscow, Russia that are not yet available in the United States. These include three B&W films and two color (slide) films. Two of the B&W films have higher infrared sensitivity than Kodak infrared. These are medium speed films with distinctive grain and excellent haze penetration. The two false-color films are similar to Kodak Ektachrome infrared, but are designed for use in aerial photography and are available in wide-roll format only.

7-3: Trial exposures for AGFAPAN APX 200S film.

Recommended filters include a No. 12 yellow, No. 16 orange, No. 25 red, No. 29 deep red and infrared filters No. 88A and 89B. Infrared flash units are not recommended. The film has excellent haze penetration, no halation, moderate grain and can be pushed up to ISO/ASA 800 and pulled to ISO/ASA 100. (See table 7-3 for processing information.)

AGFAPAN APX 200S professional film is available in Germany and will soon be available in Canada. It comes in 35mm, 36 exposure cassettes.

Printing

The highlights in a print made from a properly exposed infrared negative tend to lose detail and print in very light tones.

Also, the shadow areas tend to lose gray tone and become dark due to the increased density and high contrast of the negative. When printing time is greatly increased, highlights have more detail, gray tone and grain.

Dodging and Burning-in

If the negative is underexposed or underdeveloped, the highlights contain increased detail and gray tone, but the shadow areas lose detail and print very dark or black.

Expect to spend time dodging and burning-in prints made from the negatives. Dodging is the process of holding back light from specific areas of a print to increase or reduce detail.

Use your hands to hold back the enlarger light or a piece of cardboard taped to a stiff wire. Keep the dodging tool constantly moving to avoid producing a light toned mark on the print.

Burning-in is the process of directing light to specific areas to darken those areas, increasing or reducing detail.

Burning-in can be achieved by using an opaque mask (usually heavy paper or cardboard) with a hole in it for light to pass through. Keep the mask in constant motion, or use your hands to cast a shadow over areas of the print you want to protect from the light.

With these processes, printing times will be extended. The exposure time also depends on the aperture of the enlarger lens, size of the print, type of paper and developer.

Processing for **Kodak High Speed Infrared Film** ISO/ASA 200. Approximate developing time in minutes. Small tank, agitation at 30-second intervals.

Kodak Developer	65°F 18.5°C	68°F 20°C	70°F 21°C	72°F 22°C	75°F 24°C
D-76	13	11	10	9 1/2	8
HC-110 (Dilution B)	7	6 1/2	6	5 1/2	5
D-19	7	6	5 1/2	5	4
XTOL (1:1 dilution)	9 1/2	8 3/4	8 1/4	7 3/4	7

AGFA Rodinal developer for Kodak infrared should be a 1:75 dilution at 70°F for 7 minutes. For negatives with medium contrast, use a 1:50 dilution at 68°F for 6 minutes. All developers listed are from undiluted straight stock solution unless otherwise noted.

Note: Avoid developing tanks made of plastic as they may transmit infrared radiation.

7-4: *Processing table for Kodak High Speed Infrared Film.*

Processing for **Konica Infrared 750** ISO/ASA 50[*]. Approximate developing time in minutes. Small tank, continuous agitation for the 1st minute and for 5 seconds at 1 minute intervals.

Developer	68°F 20°C	73°F 22.5°C	75°F 24°C	77°F 25°C
Kodak D-76 or Konicadol DP	6	5	4 1/2	4
Kodak HC-110 (Dilution B)	7	5 3/4	5 1/2	5
Konicadol Fine**	7	6	5 1/2	5
Konicadol Super	6	5 1/2	5	4 1/2

AGFA Rodinal developer for Konica infrared should be a 1:75 dilution at 70°F for 5 minutes or a 1:50 dilution at 68°F for 7 minutes. Kodak XTOL developer for Konica infrared should be a 1:1 dilution at 68°F for 6 minutes.

[*]If the film is rated at ISO/ASA 64, increase development time by 10%. If the film is rated at ISO/ASA 100, increase development time by 20%.

** Equivalent to Kodak DK-20.

Note: For large tank processing, increase times by approximately one minute.

7-5: *Processing table for Konica Infrared Film.*

CHAPTER EIGHT

Toning & Handcoloring Prints

"Toners also extend the life of prints."

Toning infrared photographs can produce interesting and effective results, giving added dimension to an infrared image. Toners also extend the life of prints.

The application of a selenium toner (such as Kodak rapid selenium) will produce a slightly warmer image tone and reduce contrast in a B&W print if the toner is not heavily diluted. (A 1:3 dilution works well.)

Selenium toner diluted 1:20 for three minutes at 70°F (24°C) will not change the image color, but will provide protection and enhance the maximum density of the print.

Some prints made from Kodak infrared film have a soft and grainy appearance. Adding a sepia or brown toner to this type of image can produce a nostalgic look, reminiscent of an earlier time.

The image color obtained by toning varies according to the original tone of the B&W print.

In other words, a warmer look will be achieved using sepia or brown toner with a warm image tone paper rather than a warm image tone paper rather than cold. Prints can be toned under normal room lighting.

Handcoloring

Prints made from B&W infrared film are perfectly suited for handcoloring. Most matte finish fiber base and matte finish RC papers accept color well. Kodak P-Max Art RC paper and Luminos RCR Art paper are specifically recommended for use with many types of coloring agents.

Color can be added to infrared photographs with practically any medium used for tinting, coloring, or retouching photographic prints: liquid or dry dyes, oil-based paints, watercolors, acrylic paint, felt tipped markers, pastels or colored pencils.

Because many objects such as foliage, grass, clouds, snow, sand and people record as white or in light tones, there are many areas of a print to which color can be added. The soft, pastel hues of these coloring materials enhance the evocative look and feel of an infrared print. This allows you to create handcolored images with dream-like beauty and high visual impact.

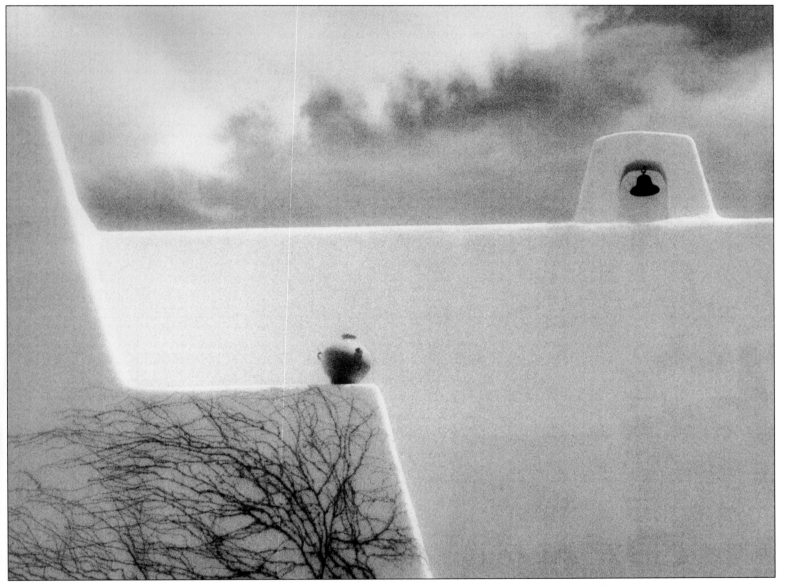

8-1: Compare this photo with one similar to it that has been handcolored (see page 49).

CHAPTER NINE
Color Infrared Film

"It is useful for creating stunning visual effects."

Kodak manufactures Ektachrome infrared, an infrared-sensitive color slide film. This is a fine grain, modified-color (sometimes referred to as false-color), ester-based film, with no anti-halation coating. It is useful for creating stunning visual effects.

The film records like-colored objects differently because it emphasizes the differences in their infrared reflectance. In addition to sensitivity from the ultraviolet through the visible spectrum, the film also has a spectral sensitivity range (daylight without a filter) from about 700 to 900 nm in the infrared region. Peak spectral sensitivity is from 740 to 840 nm.

Normal three layer color film contains three image layers: blue sensitive, green sensitive and red sensitive. Color infrared film also consists of three image layers, but the layers are altered. One layer is sensitive to red, one to green and the last to infrared. Focus adjustments for this film are not necessary. Also, because the infrared-sensitive layer is covered by the other two image layers, the film can be loaded and unloaded in subdued light, but total darkness is still recommended by Kodak.

Haze penetration is excellent with (filtered) color infrared film, and the look of the film is positively surreal. The moonlight effect created by Kodak B&W can be duplicated with color infrared by slightly underexposing the film when shooting in direct sunlight with the sun behind you. As with B&W infrared, shooting under foggy, hazy or overcast conditions or with backlighted subjects causes the sky to record very light in tone.

Because Ektachrome infrared is sensitive to blue light, the best filters to use are

- No. 12 yellow (Cokin® equivalent orange No. 002)
- No. 16 orange (Cokin® yellow No. 001)
- No. 25 red (Cokin® red No. 003)

Filter factors and exposure compensation for the filters:

- yellow (filter factor 2) — a 1 stop increase
- orange (filter factor 3) — a 1 1/2 stop increase
- red (filter factor 4/6) — a 2 - 2 1/2 stop increase

With no filtration, colors are washed out. Infrared filters are not recommended as only the color red would reproduce on film.

Color Reproduction of Vegetation

Because the chlorophyll in a healthy plant reflects a large amount of infrared radiation, color you see through the lens (and filter) will not be the color you actually get.

For example, in landscape photography, the yellow filter records grass and foliage in magenta tones, the sky in bluish-purple and water in dark blue or black. The orange filter renders foliage and grass more red in color and the sky a dark blue tone. Water will appear as dark blue or sometimes black. White objects and clouds remain white with either filter. A No. 25 red, No. 29 deep red, or a magenta filter will record vegetation as deep orange and water as dark green or black.

However, the sky will look brownish/purple with a magenta filter, but yellow/green or dark green with a red filter.

White objects remain white with a magenta filter, but will look light yellow with a red filter.

Vivid Filter Effects

Other filters may be used for vivid effects. For example, a No. 13 green filter (Cokin® filter #004) records grass, foliage and clouds in brilliant magenta tones, while retaining a natural blue in the sky.

Water, however, will appear dark blue or black. A No. 47 dark blue filter (Cokin® filter #021) renders grass, foliage, sky, water and most white objects in magenta tones.

Note: The actual colors of fall foliage will not be the colors recorded by the film, although the image will still resemble a fall scene. With color infrared film (using a yellow or orange filter), unhealthy vegetation reproduces as brown or tan.

Variable Color Filters

For multi-color filter application, use variable color filters such as Hoya's Vario Polarizing Color Filters or a Cokin® Varicolor filter. These contain two colored polarizing filters which produce two dominant colors. Hoya's Vario PL-Color filters combine a gray polarizing filter with the two colored polarizers in one mount. Color is varied by rotating the filter frames.

With the Cokin® Varicolor filter system, a separate gray polarizing filter produces the two dominant colors as well as intermediate colors when the polarizer is rotated. Variable color filters are usually available in these color combinations: yellow-blue; yellow-green; yellow-red; red-blue; red-green.

When photographing people, a yellow, orange, red or magenta filter records skin tones as yellow or yellow/green. With a blue or green filter, skin tones record as magenta or red. Dark hair color will remain basically unchanged with most filters. Blonde hair will record yellow or yellow/green with most filters but will look magenta with a blue or green filter.

Ektachrome infrared with a No. 12 yellow filter records red as green, blue as black, infrared radiation as red and green as blue.

Other colors will be created, depending on the proportions of color and infrared reflected or transmitted by an object. This is why green foliage appears magenta. This translation of the color of objects is the basis of infrared color photography.

The exciting aspect of this false-color film is that you cannot accurately predict how the color of artificial (man-made) objects will record.

Generally, with a yellow or orange filter, most red objects reproduce as yellow, and blue objects appear magenta. Until the slides are processed, you can't be sure how the actual color of an object was recorded and transformed by this amazing film.

Polarizing Filters

When using color infrared film, attach a polarizing filter over the color filter of your choice. Polarizing visible light reduces glare and saturates colors. A polarizing filter (filter factor - 4/6) absorbs about 2 to 2 1/2 stops of light.

If you are using a hand-held light meter, manual exposure compensation is required. If using the camera's meter, it will automatically compensate, unless the camera is set on manual.

With two filters attached, it might be difficult to view and focus through the lens at first, but this should become easier with practice.

Note: A circular polarizer can be used with all cameras. A linear polarizer is not effective on cameras with a split beam metering system.

Colored Polarizing Filters

A colored polarizing filter is a combination of a gray and colored polarizing filter in one filter mount. Any color from gray to the full color of the filter can be obtained by rotating the outer filter ring. These filters are usually available in blue, yellow, orange and red.

"Color is varied by rotating the filter frames."

Stacking filters or using a colored polarizing filter with wide-angle lenses can cause vignetting (the darkening of the corners of the image). To avoid vignetting, attach the polarizer to the front of the lens and tape a colored filter gel behind the rear lens element.

The suggested film speed by Kodak for Ektachrome infrared film is ISO/ASA 200 when metering through a yellow filter, or ISO/ASA 400 with no filtration.

Proper Exposure and Lighting Conditions

Color infrared film tends to slightly overexpose. To produce the correct exposure, make the first exposure at the (filtered) reading the meter indicates is correct, then close the lens down 1/2 stop and make another exposure. On a sunny day, meter from the brightest area of the scene, other than the sky. On an overcast or hazy day, or when shooting in shaded areas, meter from the overall available light.

For either lighting condition, make two exposures in addition to the exposure the meter indicates is correct.

For example, if the meter shows that 1/60 second at f/11 is correct, make that exposure. Next, close down 1/2 stop from f/11 and make a second exposure. Finally, from that exposure, close down 1/2 stop and make the third exposure. Use small apertures for maximum image sharpness. (See table 9-1.)

If using a hand-held light meter, use the meter in the reflected-light mode. Simply set the lens to the indicated f-stop. Otherwise exposure compensation is required. With a filter over the meter cell, the meter shows the correct filtered exposure.

Ektachrome infrared film can be used indoors with tungsten, fluorescent or available natural daylight. Photographs can also be taken outside at night using existing light.

Electronic flash photos can be made indoors or out, following the same procedures for B&W infrared (but using a filter for color infrared). (See table 9-2.)

However, do not use gray or colored polarizing filters for flash photography, or for indoor or night light photos.

Available night light photos can be made without filters. Even though the colors in the final image will not correspond to the actual colors, the altered color effects will differ from those photos

Suggested Trial Exposure for **Kodak Ektachrome Infrared Film**.
Approximate outdoor exposures with No. 12 Yellow Filter ISO/ASA 200.

Direct sunlight	1/125	f/16
Hazy	1/60	f/16
Light cloud cover	1/60	f/11
Moderate rain	1/30	f/8

Suggested Trial Exposure for **Kodak Ektachrome Infrared Film**.
Approximate outdoor exposures with No. 12 Yellow Filter and Polarizing Filter, or Yellow Colored Polarizing Filter ISO/ASA 200.

Direct sunlight	1/60	f/11
Hazy	1/30	f/11
Light cloud cover	1/30	f/8
Moderate rain	1/15	f/5.6

9-1: Trial exposures for Kodak Ektachrome Infrared Film.

made with filters. This is also true with indoor photos shot with tungsten or fluorescent light.

Precautions

The precautions listed in Chapter 2 for Kodak B&W infrared film also apply to Ektachrome infrared.

Furthermore, the color film is extremely sensitive to variations in temperature and humidity. Storage conditions may cause changes in color balance and overall film speed and contrast.

Unexposed color infrared film must be kept cold. Store the film in a freezer at 0° to -10°F (-18° to -23°C), in the original package. To prevent moisture condensation on the film, allow it to stand at room temperature before opening the plastic container (in total darkness or subdued light). Warm-up time is about 2 hours.

Keep exposed film cool and dry, and process the film immediately after exposure. If the exposed film cannot be processed for several days, it should be resealed in the original container and refrigerated at 55°F (13°C) or lower.

Purchasing Color Infrared Film

Most photo dealers do not stock color infrared, but will special order it for you (although you might have to order a large quantity). Otherwise buy from one of the large mail order photo companies and avoid having to purchase the film in bulk.

New Kodak Ektachrome Infrared

Kodak Ektachrome Professional Infrared EIR 2236 film (available in 36 exposure 35mm cassettes) will replace Kodak Ektachrome Infrared Film IE. The film can be processed by Kodak or a local lab using E-6 chemistry, rather than a specialty lab.

Kodak recommends that the new film should be loaded and unloaded in total darkness, as it does not contain an anti-halation coating.

From personal experience however, loading in subdued light is not a problem, but to be safe, advance the film several frames to allow for possible fog exposure. If unloading the film from the camera in subdued light, remove the canister and immediately seal it in the original plastic container.

Also similar to Kodak B&W infrared, light piping can fog the film. Refer to Chapter 7 for detailed information.

Shoot the new Ektachrome infrared film at ISO/ASA 200 and make exposures at -1/2 stop increments, because the film

> "The film can be processed by...a local lab..."

Indoor Electronic Flash Guide for **Kodak Ektachrome Infrared Film** with a No. 12 Yellow Filter or Gel (ISO/ASA 200)*

Flash-to-Subject Distance (in feet)	f-stop	Shutter Speed	Flash and Camera Setting
5	f/16	1/60	Manual
10	f/8	1/60	Manual
15	f/5.6	1/60	Manual
20	f/4	1/60	Manual

*Based on use with a Sunpak BZ 2600 unit.

The exposure compensation of a 1 stop increase for the No.12 Yellow Filter has already been adjusted in this table.

9-2: Indoor Electronic Flash Guide for Kodak Ektachrome Infrared Film.

9-3: The spectral sensitivity of Kodak's Ektachrome Infrared Film.

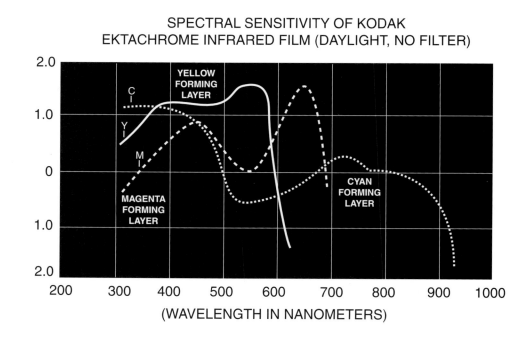

SPECTRAL SENSITIVITY OF KODAK EKTACHROME INFRARED FILM (DAYLIGHT, NO FILTER)

tends to slightly overexpose. A slight underexposure (using a yellow or orange filter) will cause a blue sky to appear dark blue-gray and vegetation to appear more red than magenta.

The film can also be processed in EA-5 chemicals using process AR-5 if using an ISO/ASA of 100.

Note: There is no DX coding information on the film canister. Manually set the film speed or the camera will select a pre-programmed speed of approximately ISO/ASA 100. If a higher speed is desired, i.e. ISO/ASA 200, decrease the exposure by 1 stop.

When presenting color infrared to the photo store or lab, inform them that the film is infrared and should not be removed from the original container prior to processing. If the photo store sends the film to an outside lab, make sure the lab is cautioned by the store that the container remain sealed until it is processed.

Helpful hint: Ektachrome infrared film can also be pushed (ideally up to ISO/ASA 400). So if the film is rated above ISO/ASA 200, alert the processing lab so

that processing times can be adjusted accordingly. Check first to see if the lab will make the adjustment, as most labs only process film at a specific processing time.

Determine if the film lab you choose uses processing equipment with infrared cameras or infrared sensors, as these will fog the film. (Many roller transport machines use infrared sensors to detect the length and width of film for calculating chemical replenishment.)

If the lab does use such equipment, it must be willing to shut off infrared cameras or use the transport machine's manual mode which will shut off the sensors to safely process the film.

Film fogged by infrared in the lab has an overall crimson appearance, leaving only an image from the red and green sensitive layers. If you wish to process your own film, see tables 9-4 and 9-5.

Enlargements and duplicate slides can be made directly from color infrared slides, or an internegative can be made and a color print made from the internegative. Also, slides can be scanned for photo CD applications.

E-6 Processing Procedure for Kodak Ektachrome Infrared Film ISO/ASA 200
Rack and Tank Processing

Chemical and Sequence	Time (in minutes)	Temperature
First Developer	6	98°-103°F (36.7°-39.4°C)
Wash (running water)	2	92°-103°F (33.3°-39.4°C)
Reversal Bath	2	75°-103°F (24°-39.4°C)
Color Developer	6	98°-103°F (36.7°-39.4°C)
Pre-Bleach II	2	75°-103°F (24°-39.4°C)
Bleach	6	92°-103°F (33.3°-39.4°C)
Fixer	4	92°-103°F (33.3°-39.4°C)
Wash (running water)	4	92°-103°F (33.3°-39.4°C)
Final Rinse	1	75°-103°F (24°-39.4°C)

Dry as needed at a maximum temperature of 140°F.

With nitrogen or air agitation, use 2 second bursts with an 8 second interval between bursts.
No agitation for reversal bath, pre-bleach or final rinse.

9-4: *E-6 Rack and Tank Processing Procedure for Kodak Ektachrome Infrared Film.*

E-6 Processing Procedure for Kodak Ektachrome Infrared Film ISO/ASA 200*
Small Tank (Nominal Process)

Chemical and Sequence	Time (in minutes)	Temperature (°F)	Agitation
First Developer	6	100.4 ± 0.5	Int. and Sub.
Wash	1	92 to 102	Int. and Sub.
Wash	1	92 to 102	Int. and Sub.
Reversal Bath	2	92 to 102	Initial only
Color Developer*	6	100.4 ± 2	Int. and Sub.
Pre-Bleach	2	92 to 102	Initial only
Bleach	7	92 to 102	Int. and Sub.
Fixer	4	92 to 102	Int. and Sub.
Final Wash	6	92 to 102	Int. and Sub.
Final Rinse	1	92 to 102	Initial only
Dry	As needed	Up to 140	

*Maintain the temperature within ±1.1°F, and control the time within ±15 seconds.

9-5: *E-6 Small Tank Processing Procedure for Kodak Ektachrome Infrared Film.*

CHAPTER TEN
Digital Infrared Cameras

"Haze penetration is excellent..."

Kodak now offers non-film technology to allow you to capture high-quality B&W digital infrared images instantly with professional DCS IR Digital Cameras.

There are two models currently available: the Kodak DCS 420 IR and the Kodak EOS DCS 5IR.

Both cameras offer the familiar function of an SLR camera. The DCS 420 IR combines Kodak's advanced imaging technology with a Nikon N90 camera, while the EOS DCS 5IR employs a Canon EOS-1N camera. Both provide expanded light and extended sensitivity into the near infrared spectrum. In addition to some ultraviolet sensitivity, and visible light sensitivity from around 400 nm to 700 nm, both cameras also have a spectral sensitivity range from about 700 to 1,000 nm in the near infrared region. Peak spectral sensitivity is around 840 nm.

Digital Infrared Camera Features

Both camera models allow room to experiment and find the right image easily. The cameras deliver a resolution of 1012 x 1524 pixels (4.5 MB file), providing rapid access to detailed infrared images for immediate computer analysis.

Both camera models function as either a visible-spectrum monochrome camera when used with a filter that blocks infrared (like a Kodak hot mirror), or as an infrared monochrome camera when used with red, orange or opaque infrared filters.

TTL metering through the infrared filter is possible, but more accurate exposures can be achieved by metering without the filter and then making the manual exposure compensation for the filter.

As with a camera and infrared film, the digital infrared cameras also require a focus adjustment in order to record infrared radiation as a focused image.

Digital infrared images have the look of prints made from conventional Kodak infrared film. Blue skies record black and vegetation white. Haze penetration is excellent, and a slight halo effect (from objects that reflect a great deal of infrared radiation) will be evident — especially against a dark or black sky.

Exposure and Flash

The cameras can be rated at any speed they allow (100 to 800 ISO/ASA for the DCS 420 IR and 200 to 800 for the EOS DCS 5IR). ISO/ASA 200 produces images with good contrast and detail. At ISO/ASA 200, basic exposure settings are similar to those for Kodak infrared film at ISO/ASA 200. (Follow table 5-1, page 21.)

Once a film speed is set, make multiple exposures because the cameras tend to overexpose the image (based on filtered meter readings).

For the first exposure, close down 1 stop from the correct meter reading, then close down 1 additional stop for the second shot.

Special infrared flash units can be used with either camera, or a red or orange gel can be placed over a conventional electronic flash. Of course a red, orange, or infrared filter can also be placed over the lens when making infrared flash photos. Once the images are in the computer, they can be manipulated depending on the complexity of the software being used. Contrast and detail can be increased or decreased. A sepia coloration can be

added, as well as colors applied to duplicate the appearance of a hand-colored B&W infrared print.

The Kodak Professional DCS 420 IR camera consists of a special electronic back fixed to the body of a Nikon N90 camera. It is a high-performance camera that offers superior image quality with today's most advanced capabilities. The camera accepts all f-mount lenses offered for the Nikon N90. It offers all of the Nikon's standard SLR features, including automatic exposure, flash and self-timing.

Digital Images with the DCS 420 IR

To capture images, simply compose, focus for infrared and shoot. Total resolution is 1.5 million pixels. The DCS 420 IR offers equivalent ISO/ASA from 100 to 800.

Once the camera is powered up, the time to the first shot is only 0.25 second. By holding the shutter button down, the camera can fire off a five-image burst in just 2.25 seconds.

The camera stores images on removable media compatible with its PCMCIA-ATA slot.

This allows photographers to carry along as much storage as they need. The camera serves as a card reader once you are ready to retrieve images.

A standard SCSI cable connects the camera directly to a Macintosh computer or (using a host adapter) to an IBM PC or compatible system.

Kodak software shipped with the camera enables Macintosh users to acquire image information from the camera's card reader directly to Adobe Photoshop software. Separate Kodak software allows PC users to move image information into Aldus PhotoStyler software or other compatible TWAIN-compliant application.

Digital Images with the EOS DCS 5IR

The Kodak Professional EOS DCS 5IR Camera shares many of the characteristics of the Kodak DCS 420 IR model. Features include a burst rate of 2.3 images per second for 10 images (enabling the capture of up to 10 images in just over 4 seconds), with a time to the first shot of less than 0.25 second.

The camera also contains the advanced functions found on the Canon EOS-1N camera as well as compatibility with all Canon EF lenses and EOS accessories. The EOS DCS 5IR has an advanced 1.5 megapixel CCD sensor and a removable PCMCIA storage (both hard disk and flash memory cards). The camera contains exposure equivalents from ISO/ASA 200 to 800 and produces high-quality images with rapid turnaround.

Kodak software shipped with the camera enables both Macintosh and PC users to acquire image information from the reader card of the camera.

A standard SCSI cable connects the camera directly to a Macintosh computer or (using a host adapter) to an IBM PC or compatible system.

Digital Color Infrared Cameras

Kodak also produces a digital color infrared camera that captures 36-bit color (12 bits per RGB color) with CCD resolution of 1.5 million pixels. The Kodak professional DS 420 CIR is a modified Nikon N90 camera with features similar to the DCS 420 IR.

Equivalent ISO/ASA ratings are from 100 to 400, and the camera has visible light sensitivity from 400 to 700 nm with infrared sensitivity up to 1000 nm. Peak sensitivity is around 840 nm.

Using the supplied yellow/orange filter produces magenta-colored vegetation. Other color filters can be used to produce an array of modified colors, and the camera can also be filtered for recording natural color. (Refer to table 9-1, page 32 for exposure information.)

Similar to color infrared film, various color filters or gels can be used when making flash exposures.

"To capture images, simply compose, focus...and shoot."

Portfolio

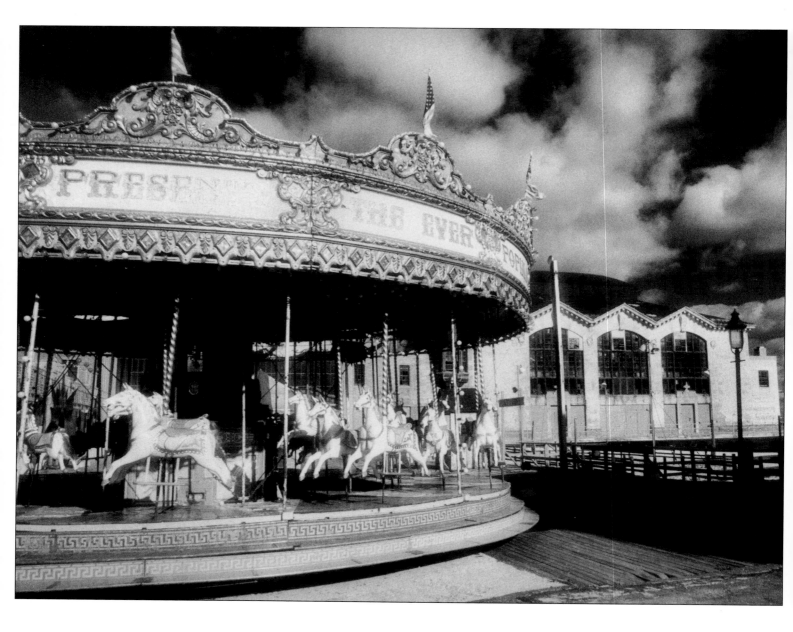

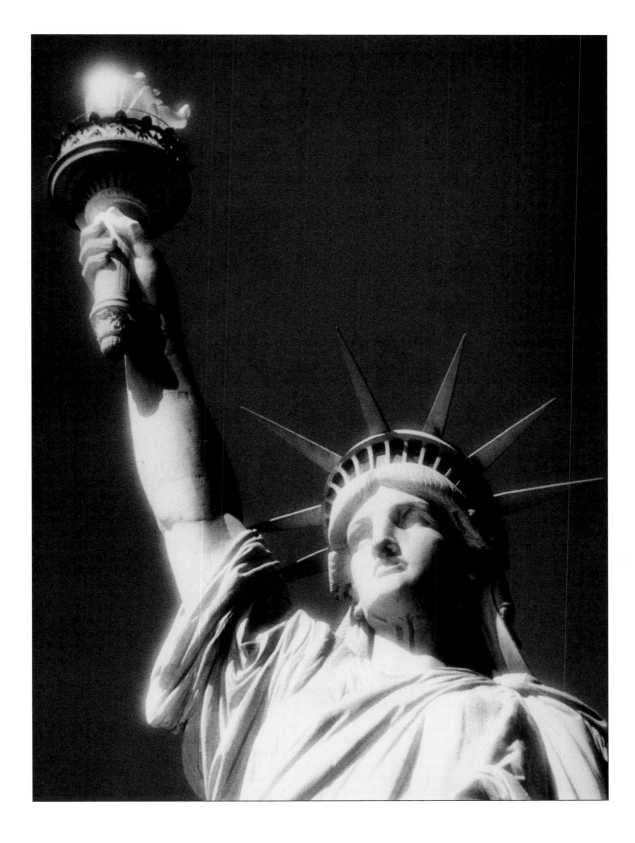

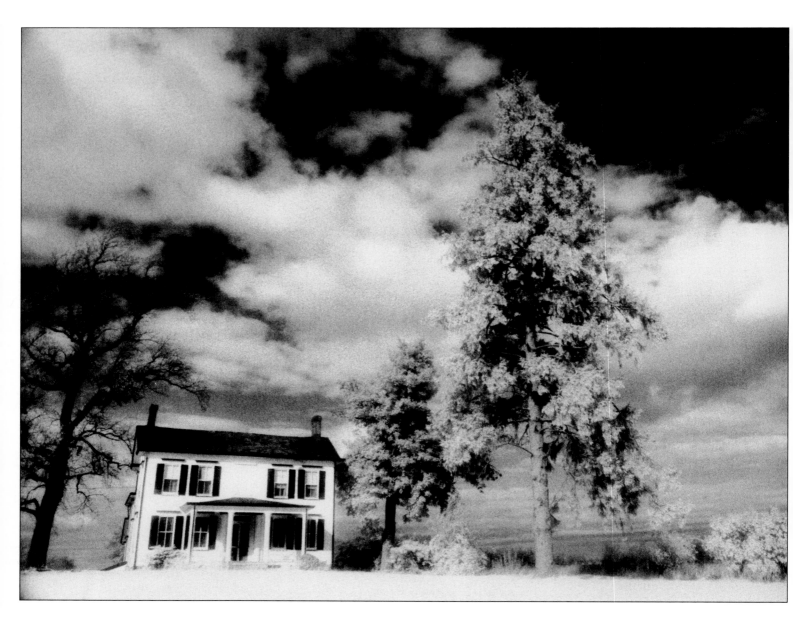

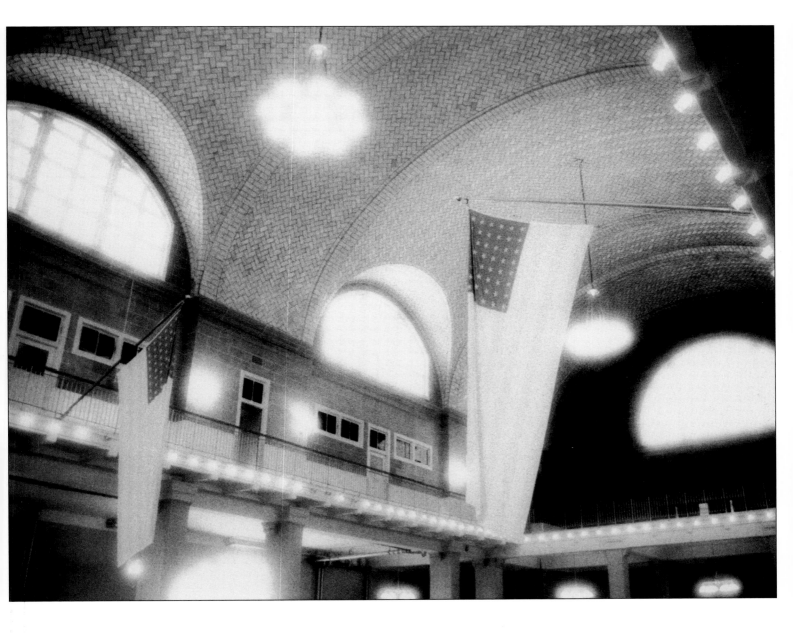

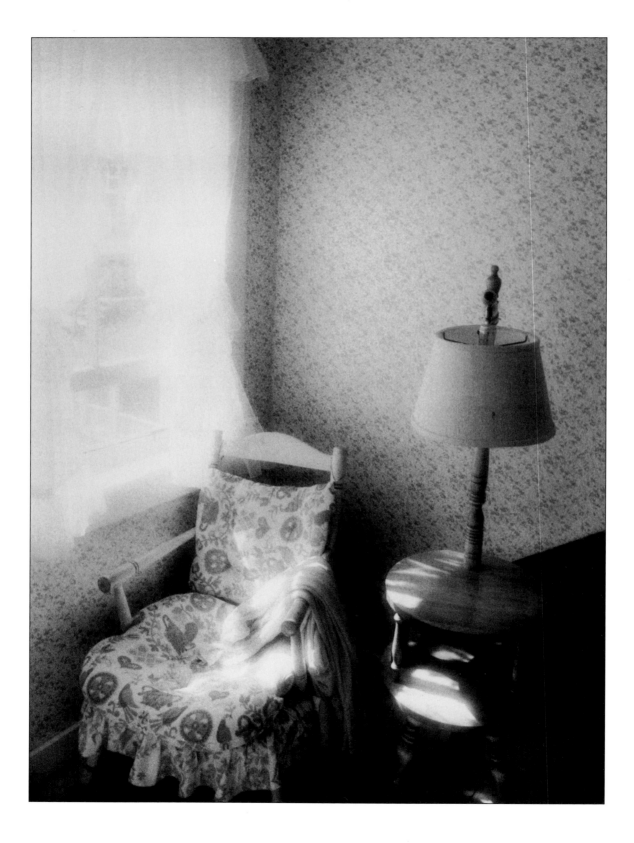

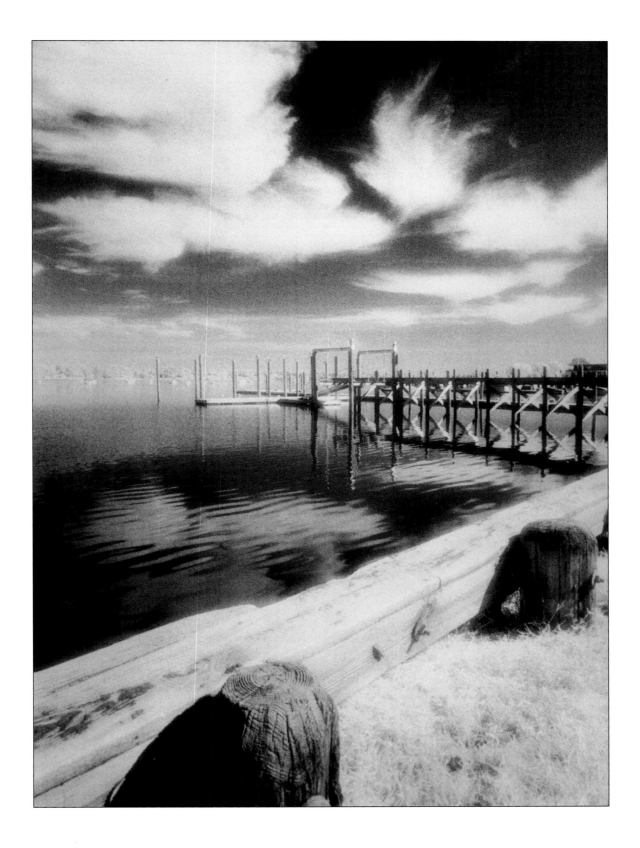

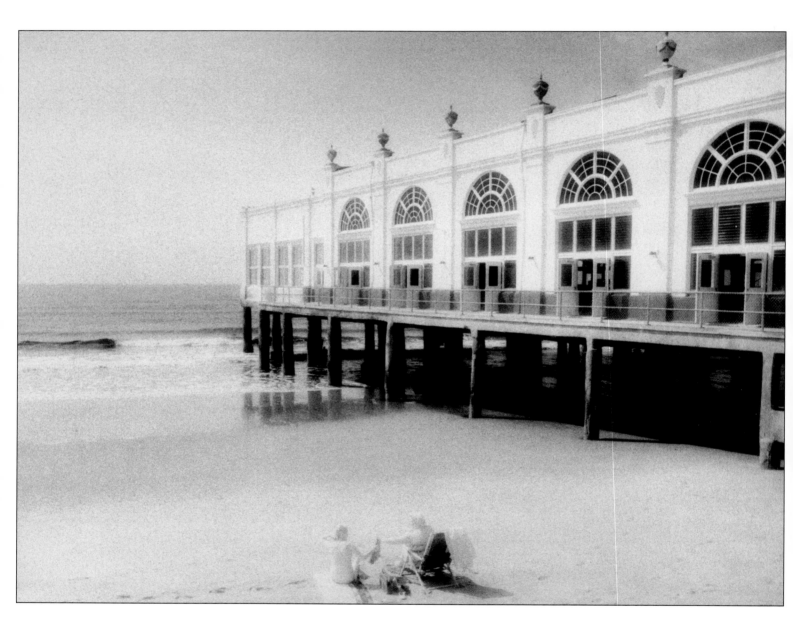

Handcolored

Handcolored

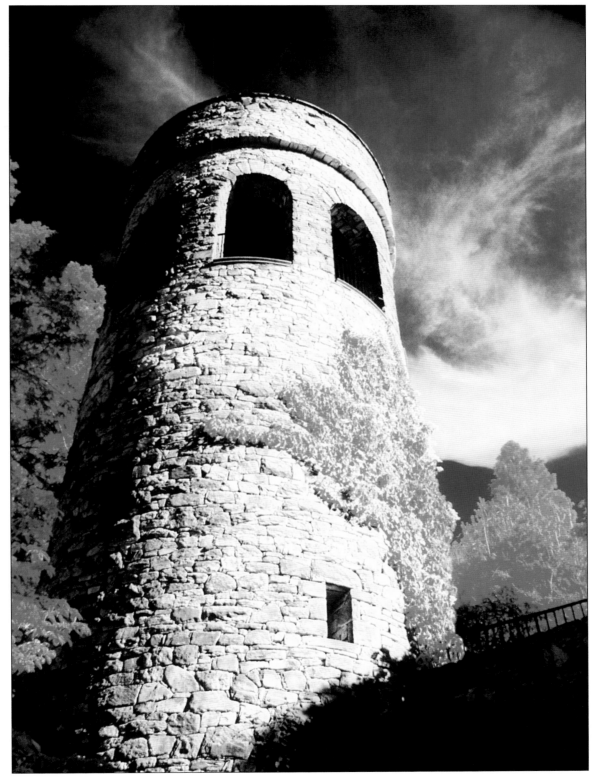

Color infrared

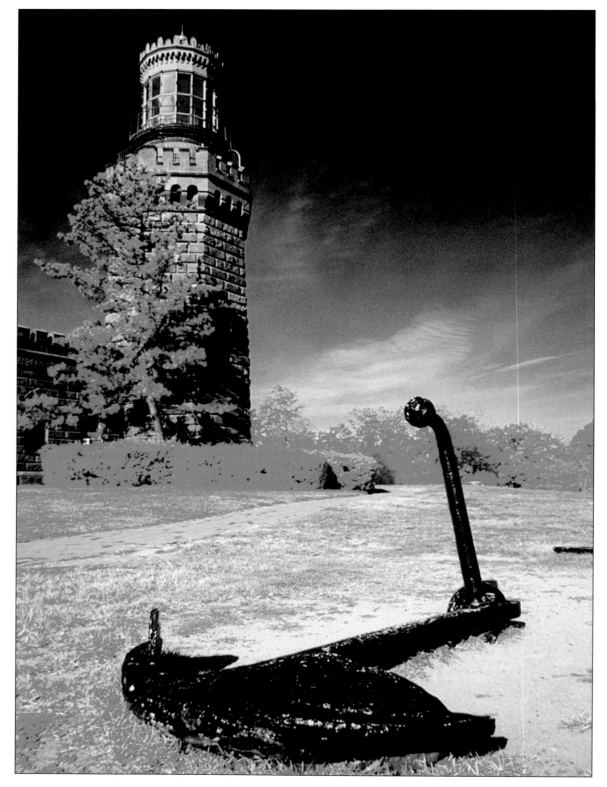

Color infrared

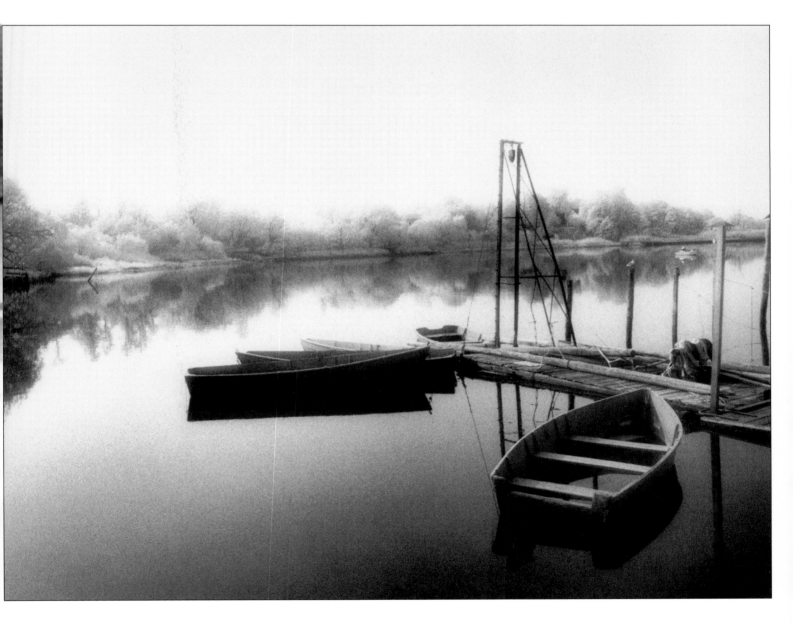

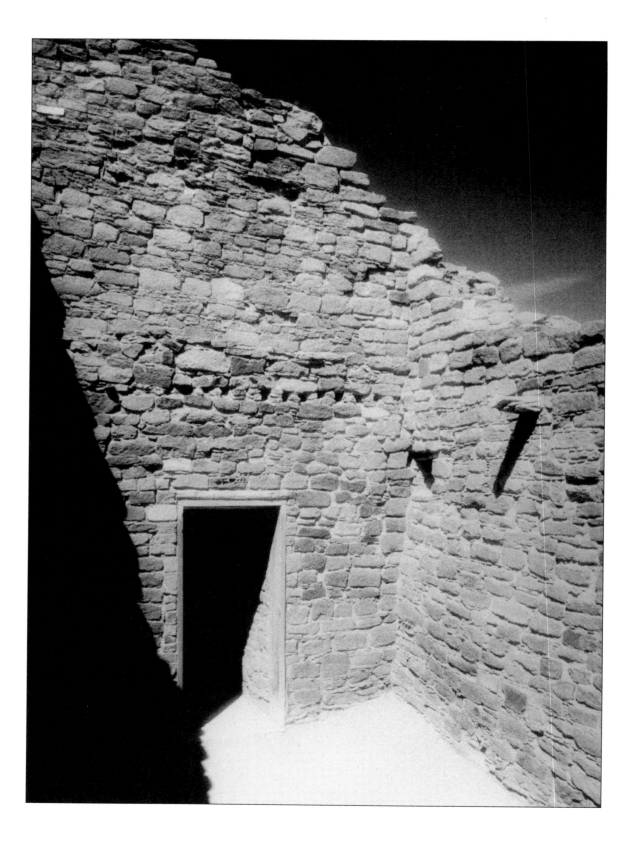

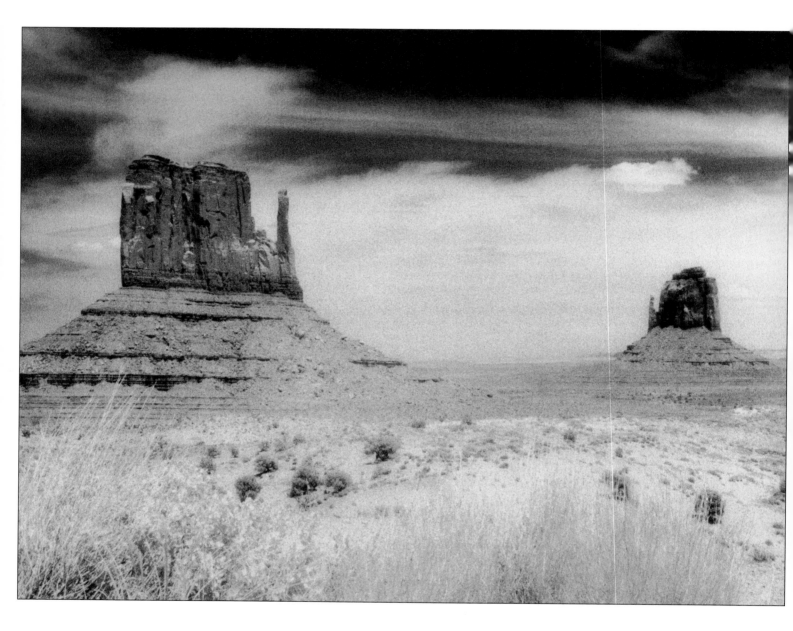

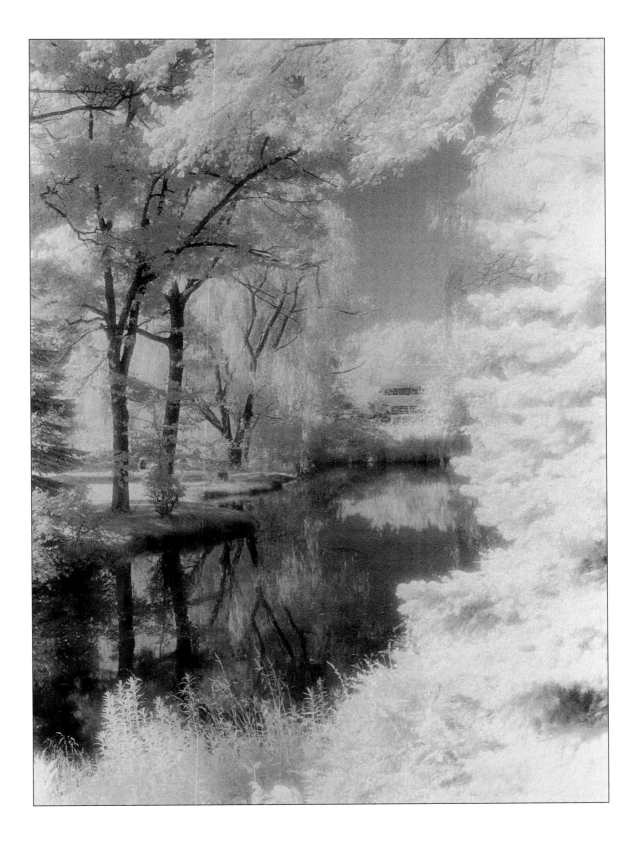

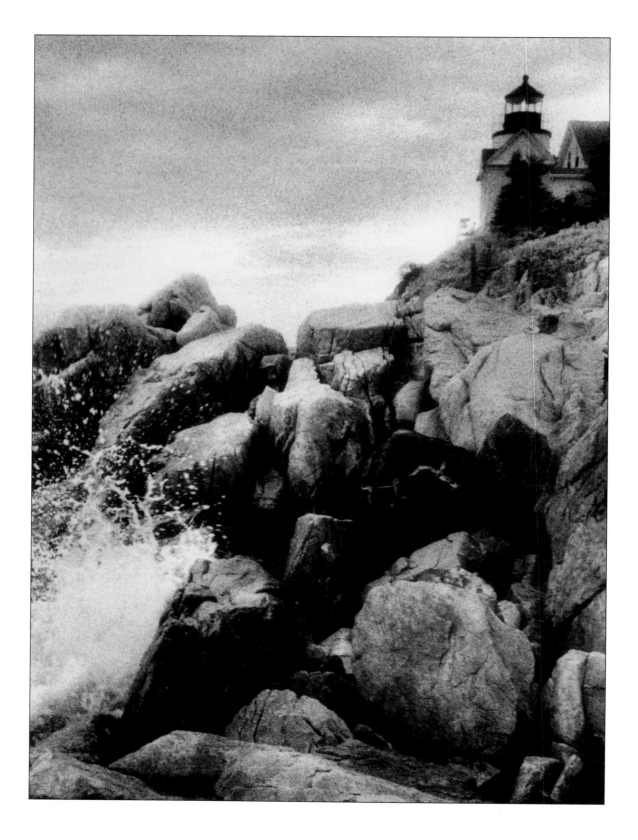

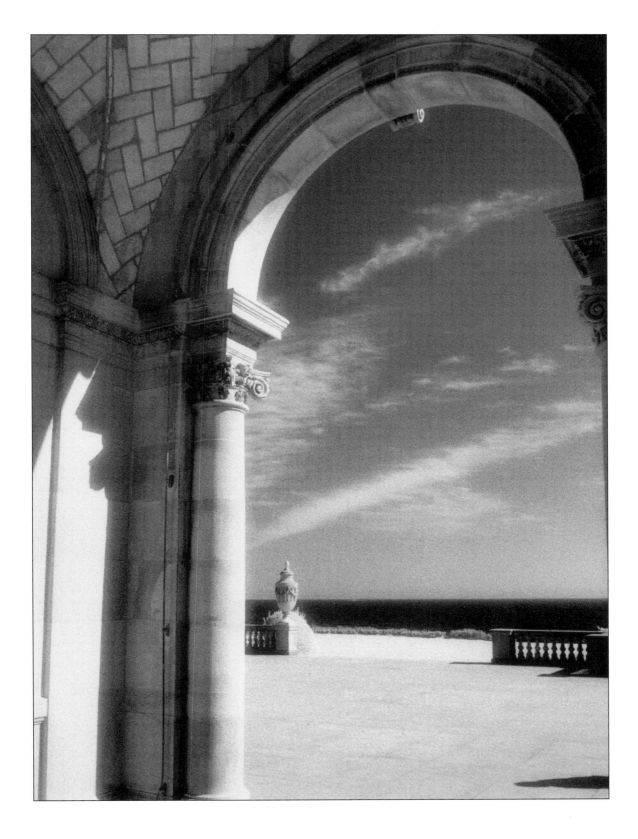

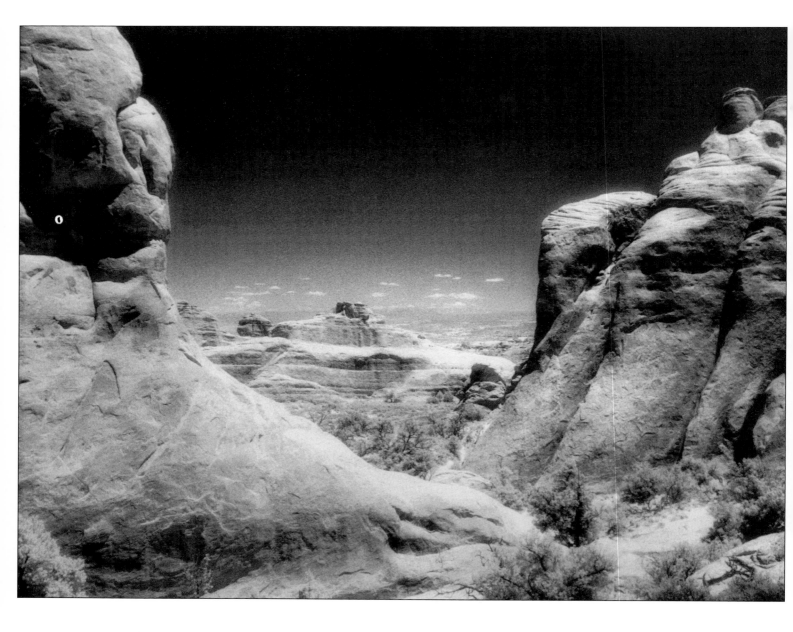

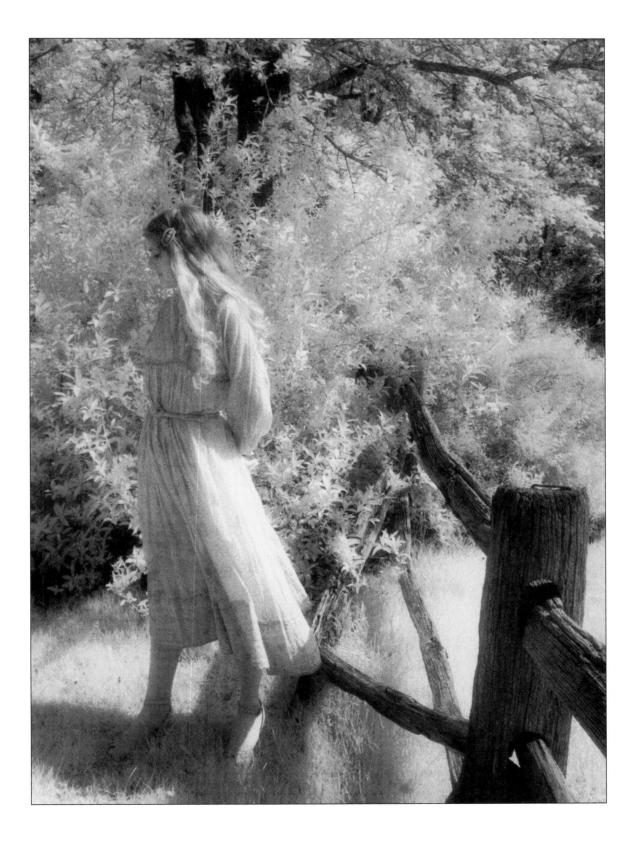

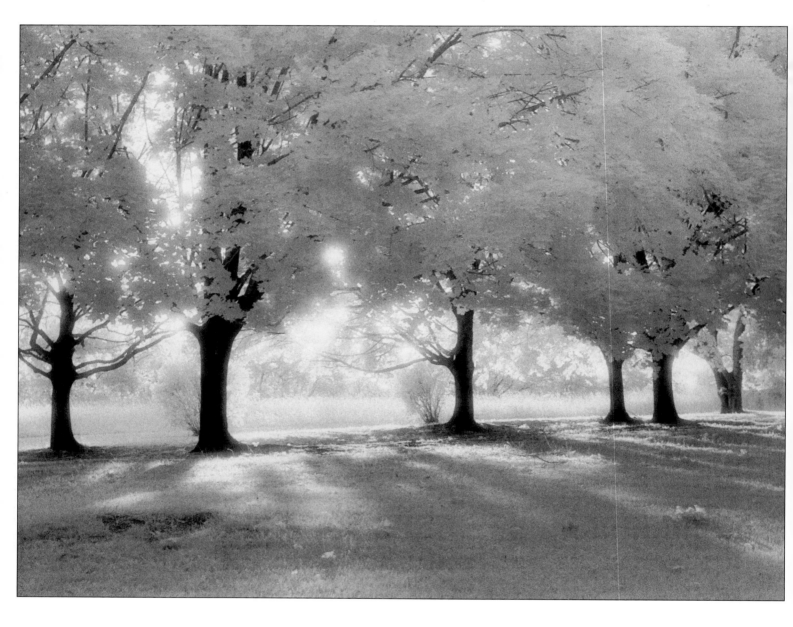

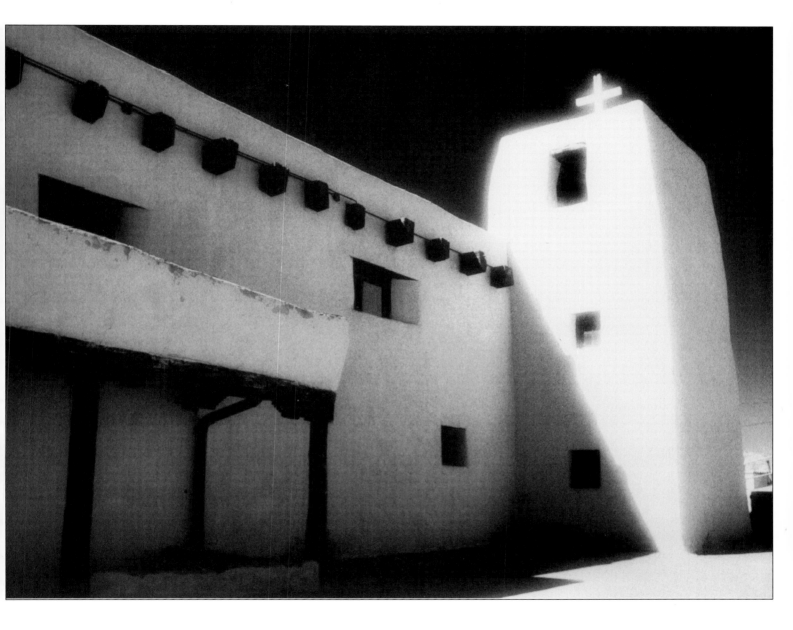

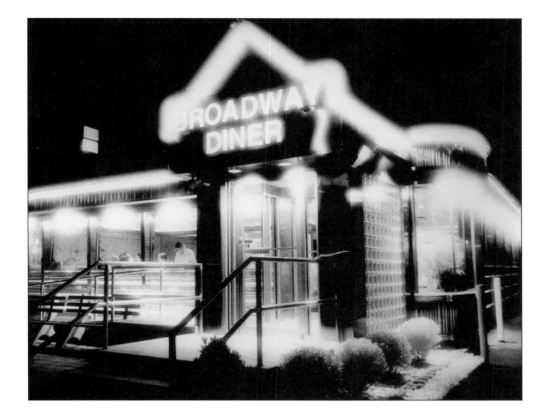

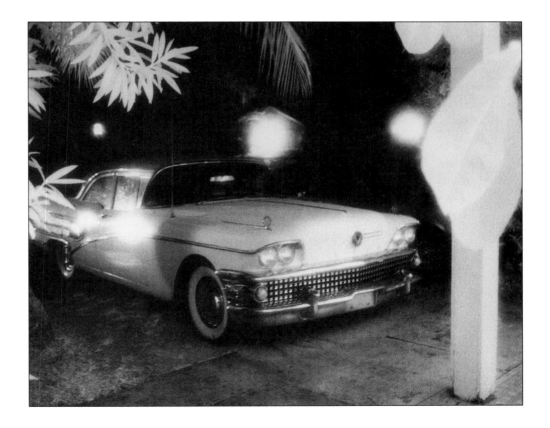

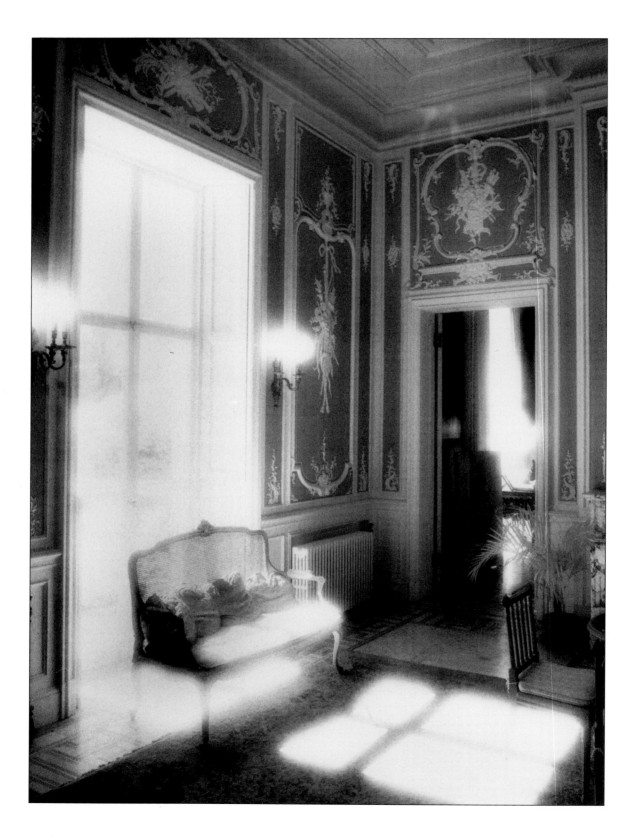

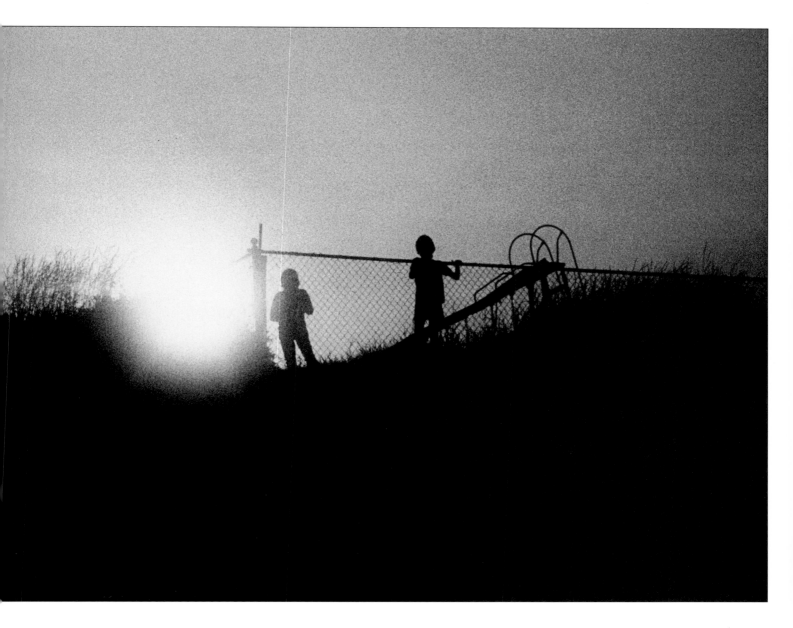

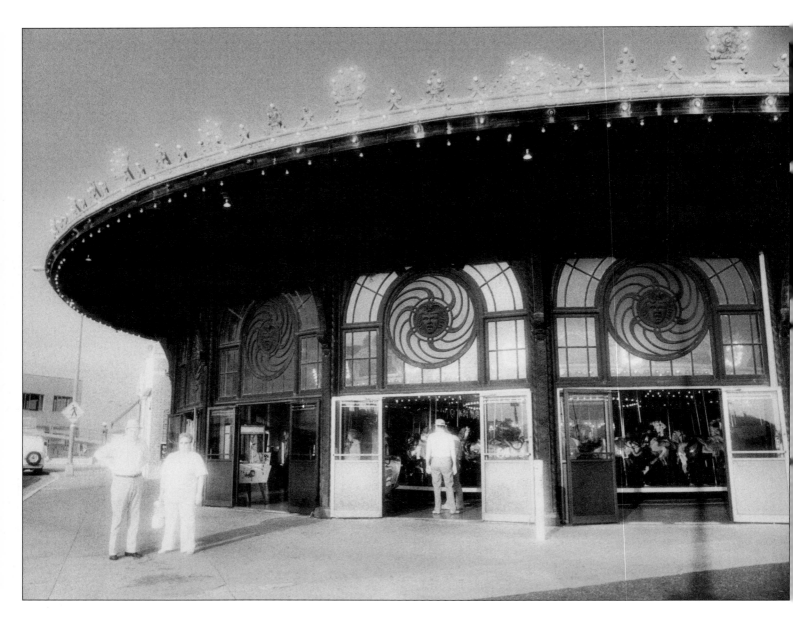

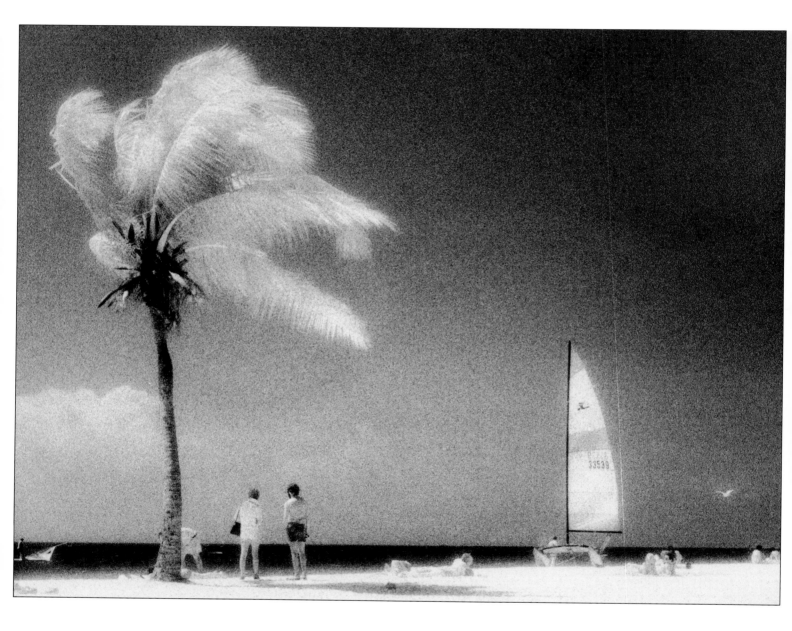

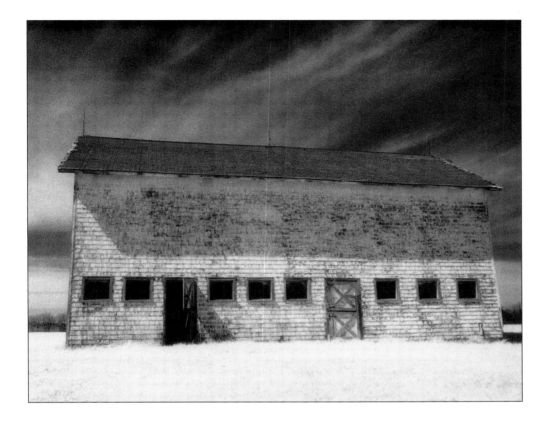

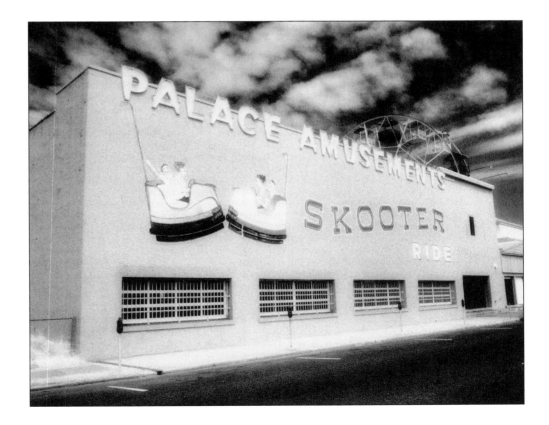

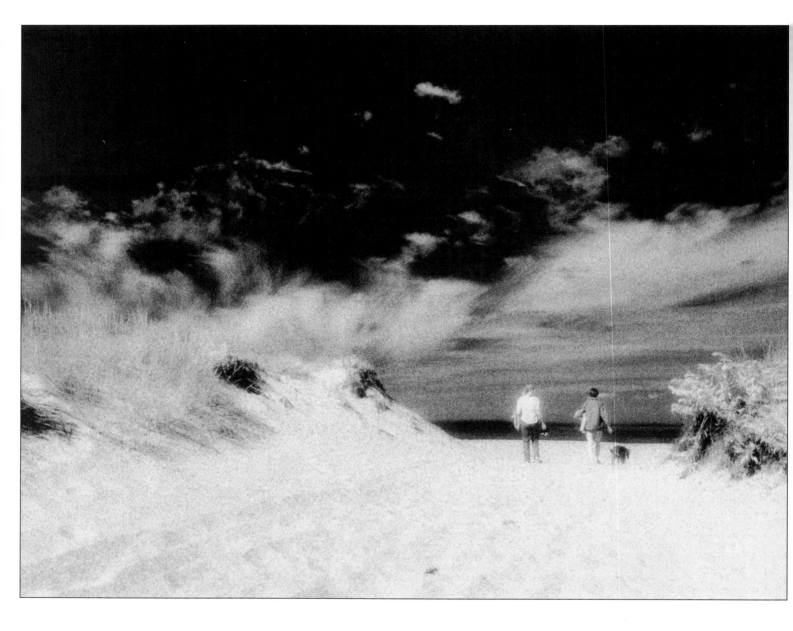

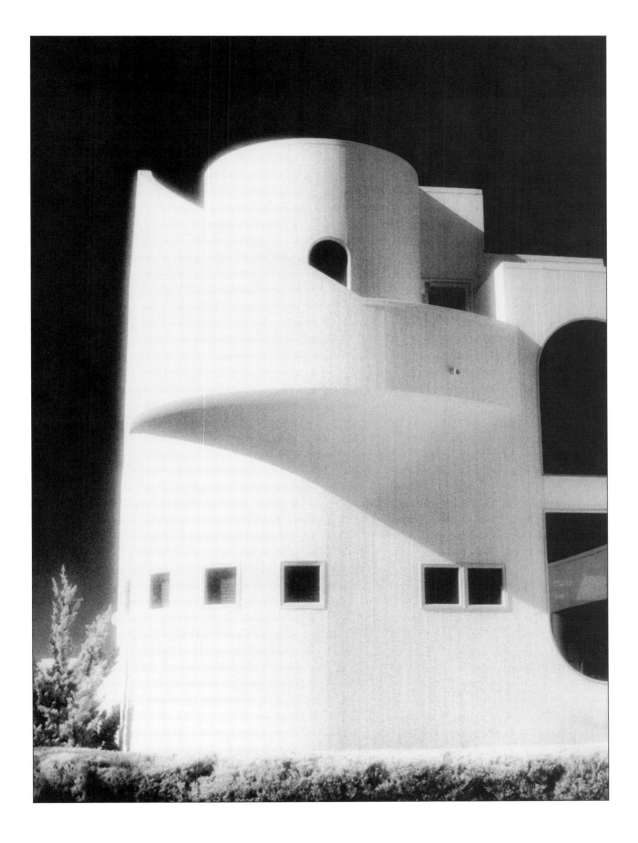

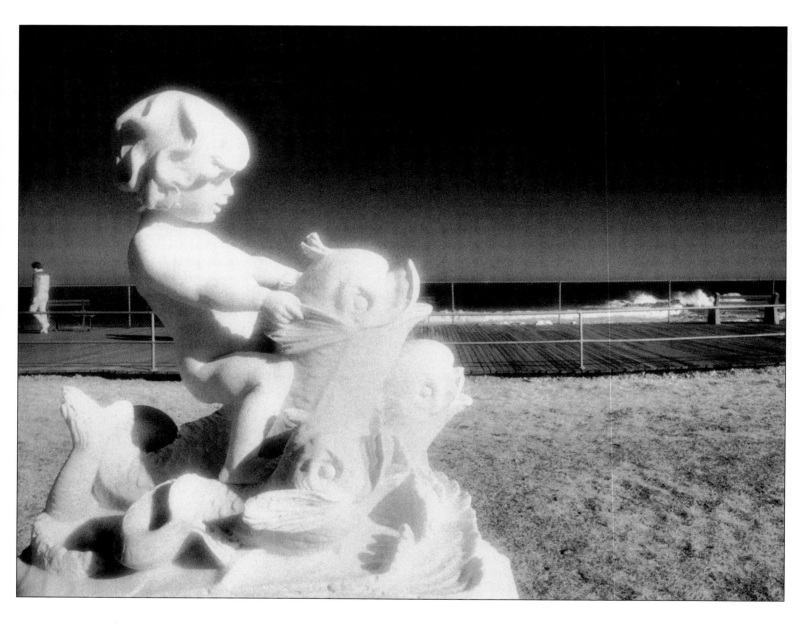

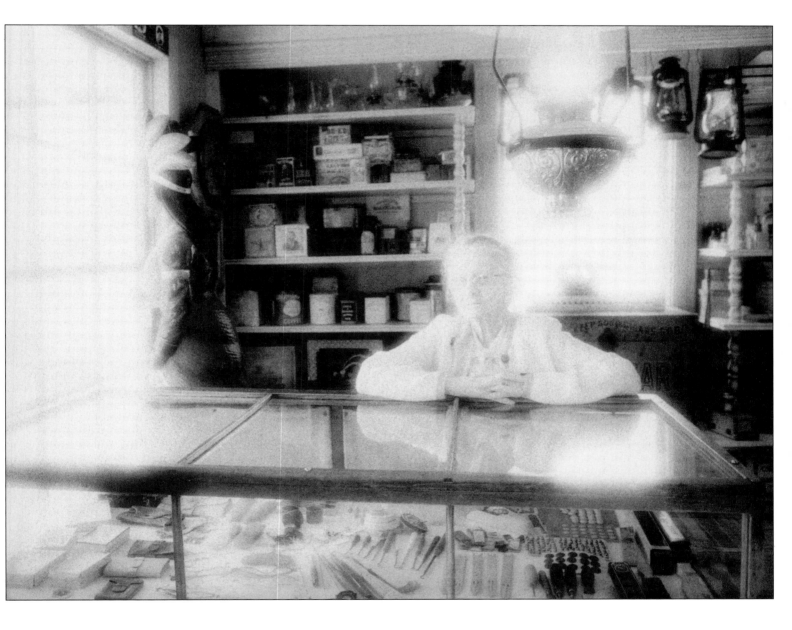

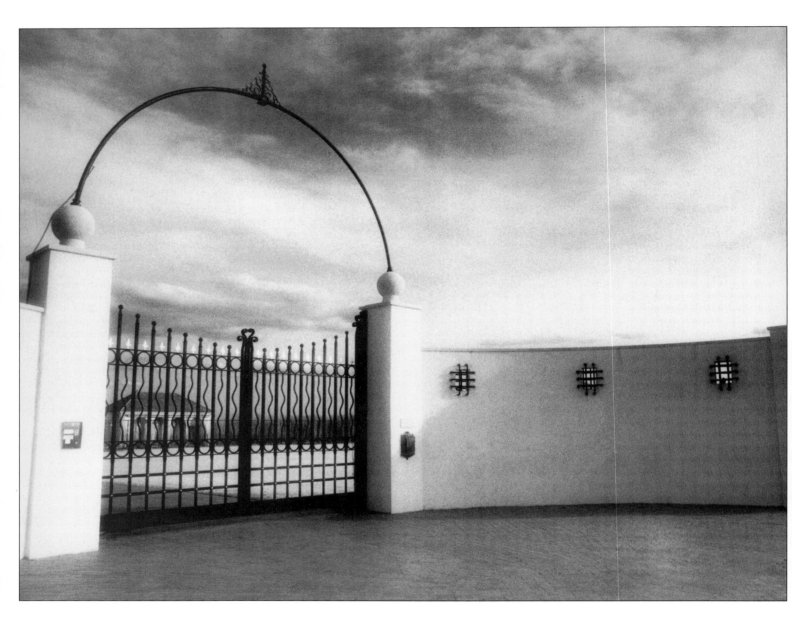

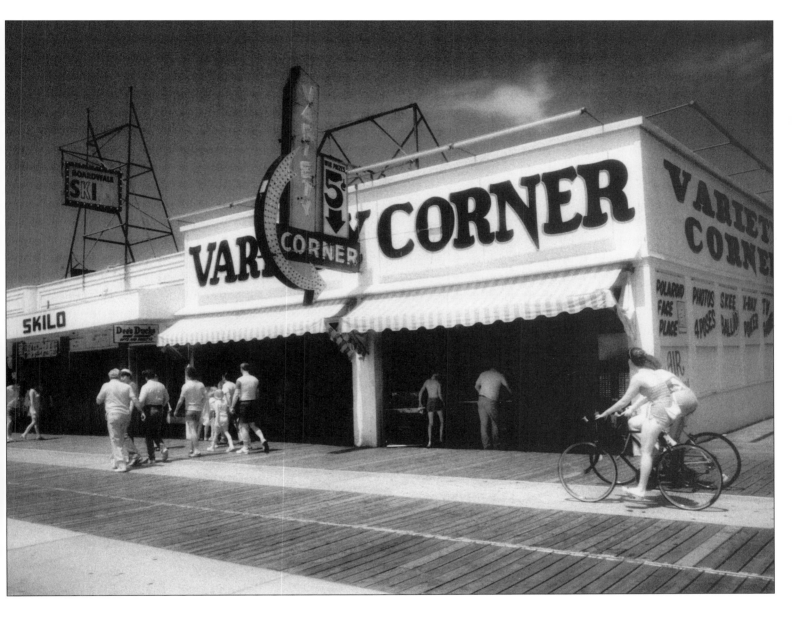

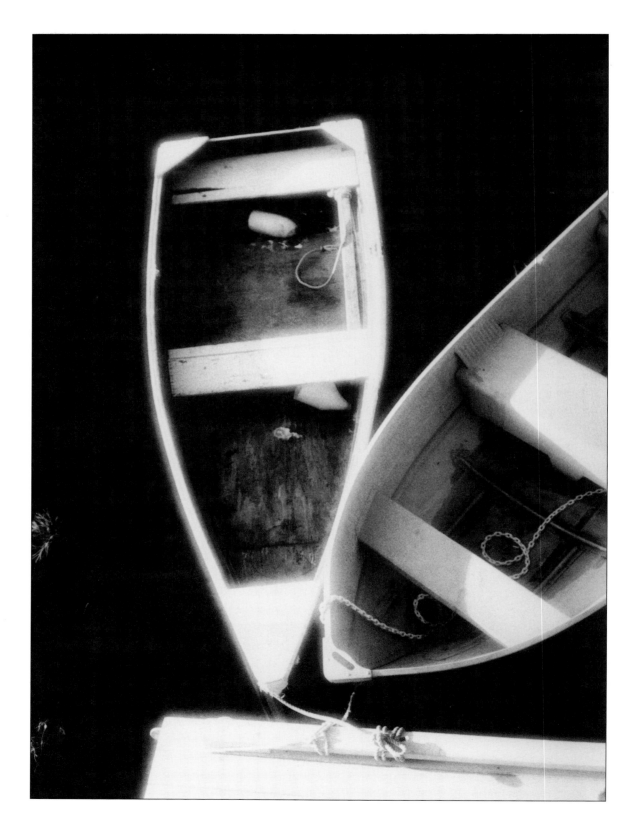

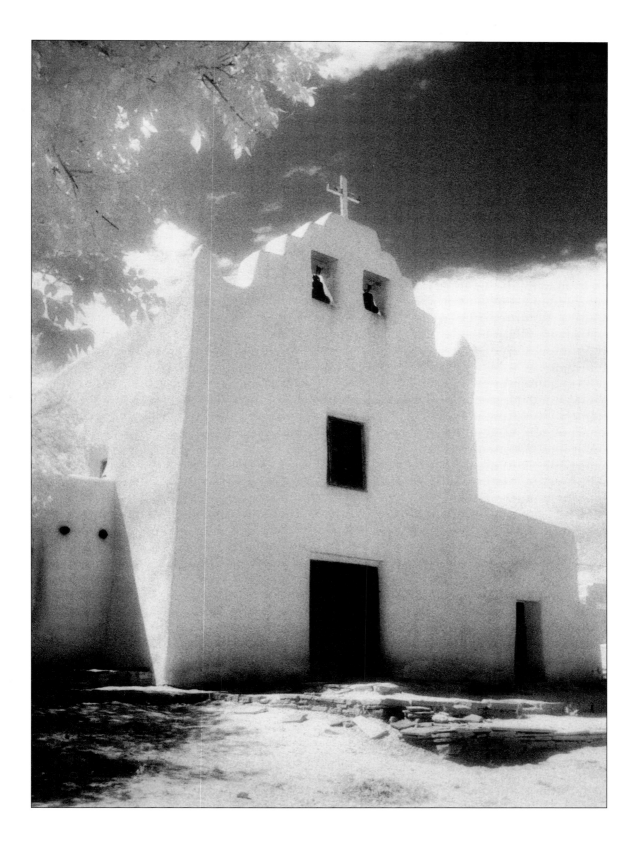

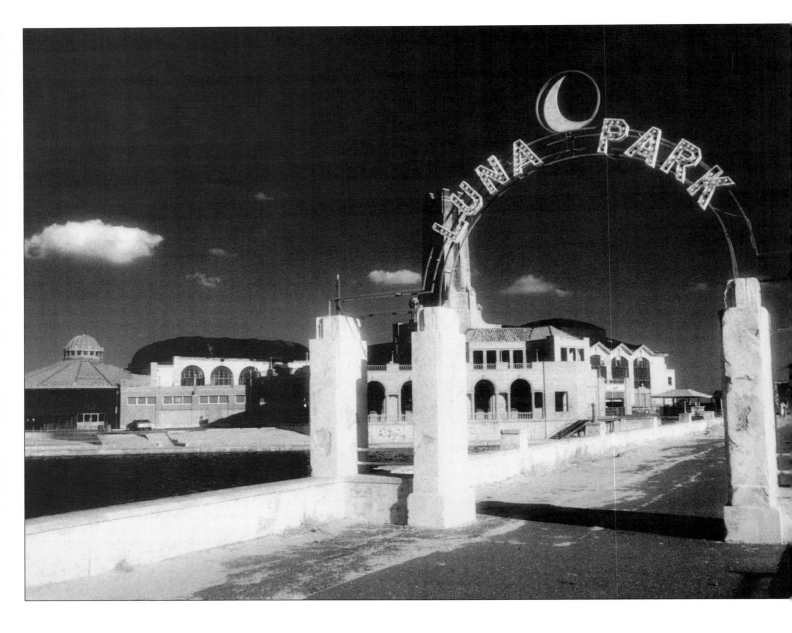

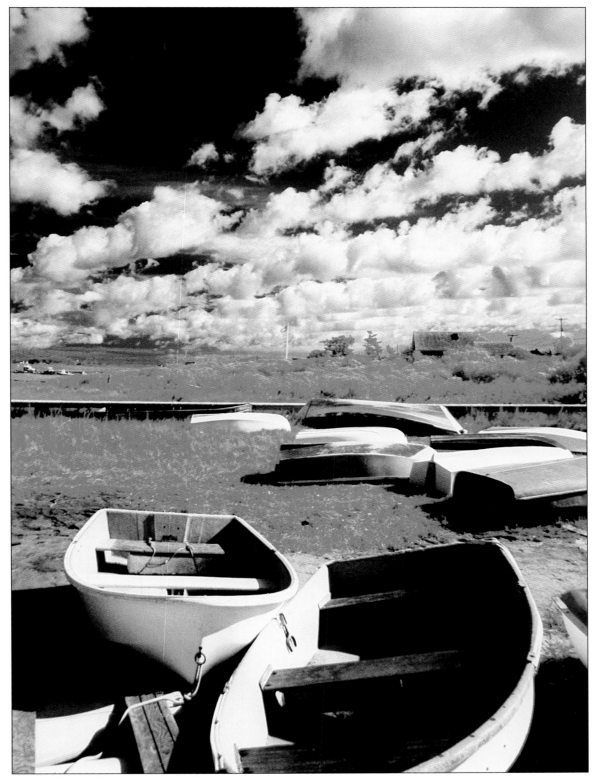

Color infrared

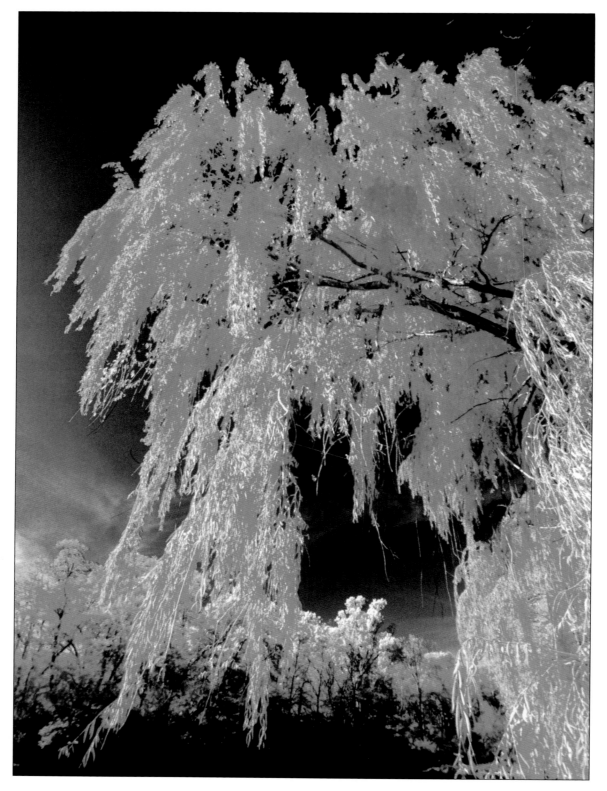

Color infrared

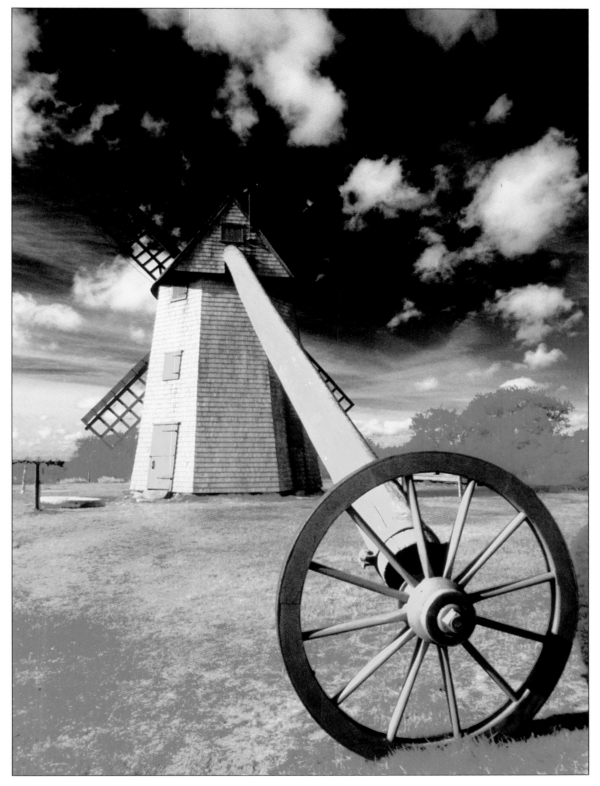

Color infrared

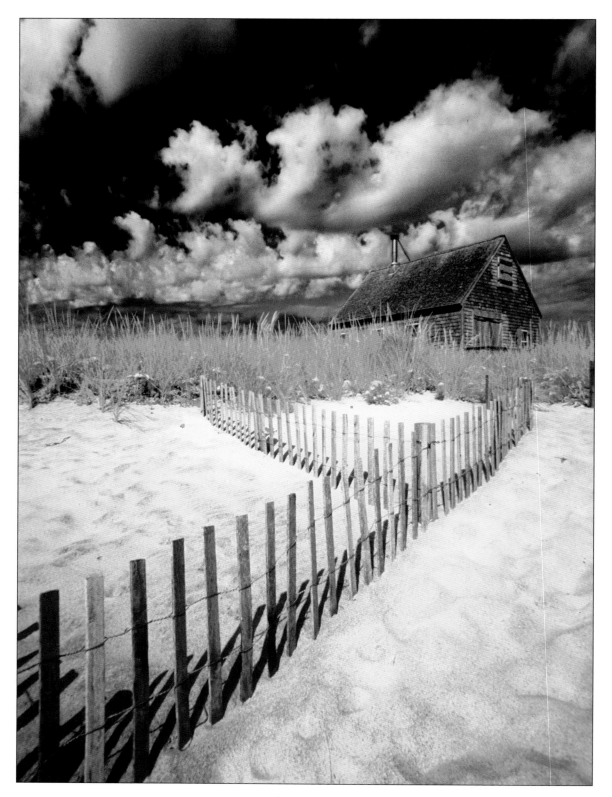

Color infrared

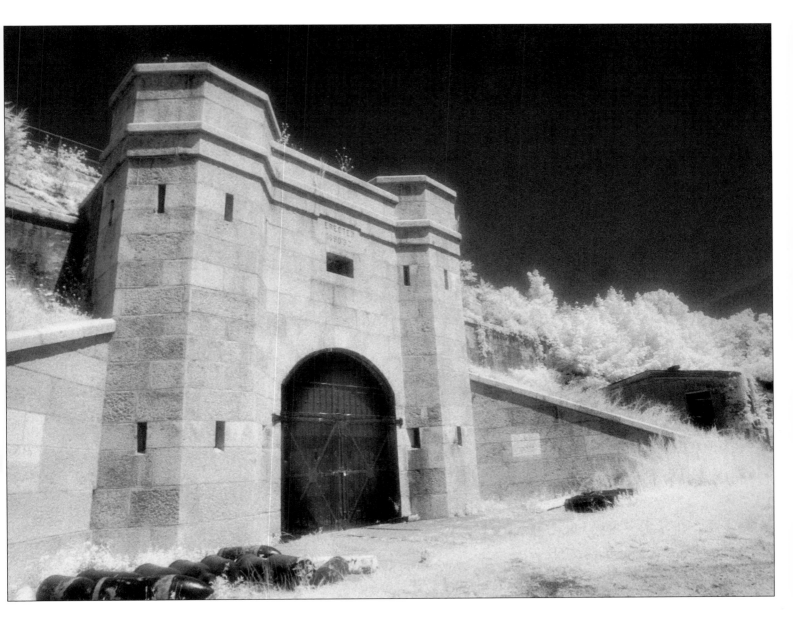

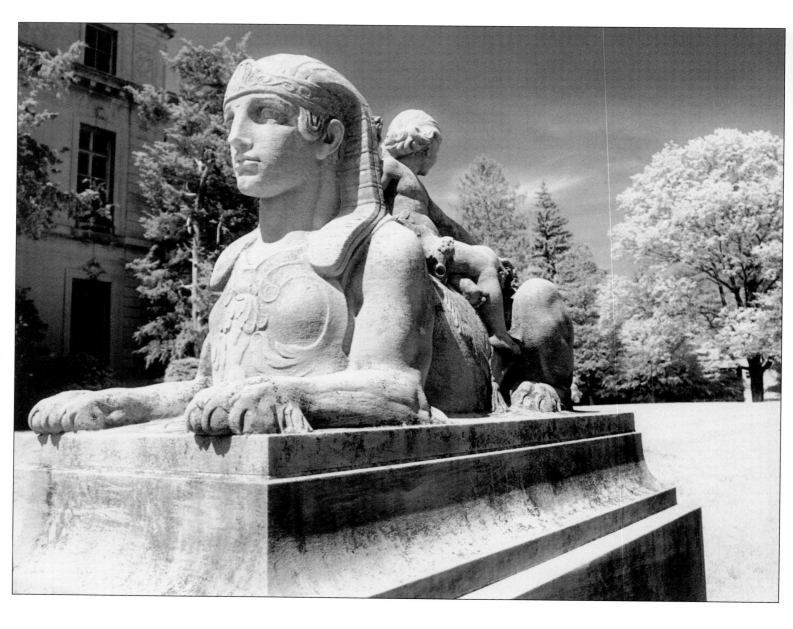

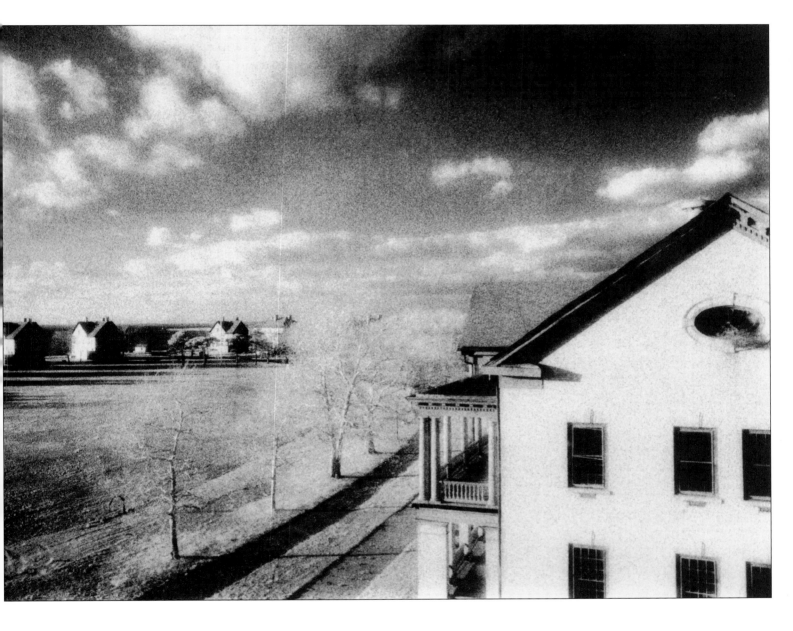

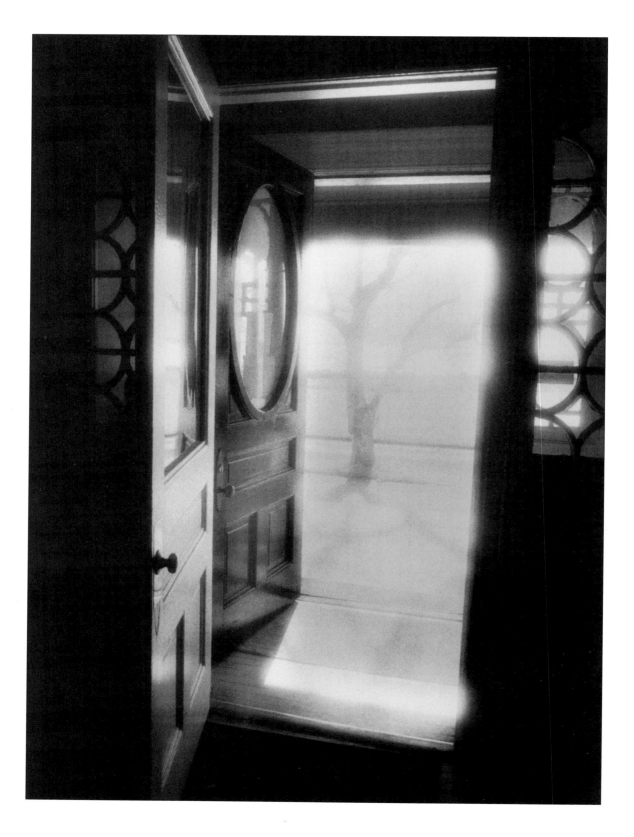

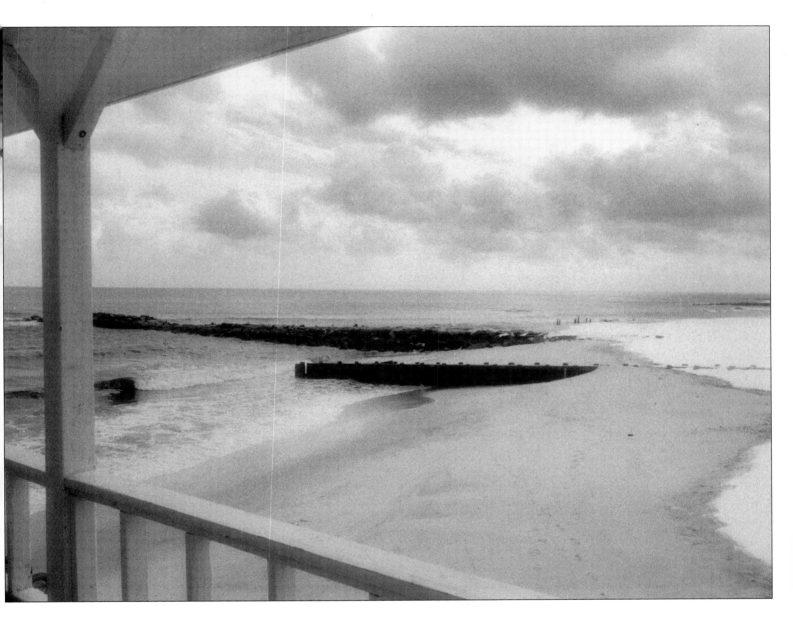

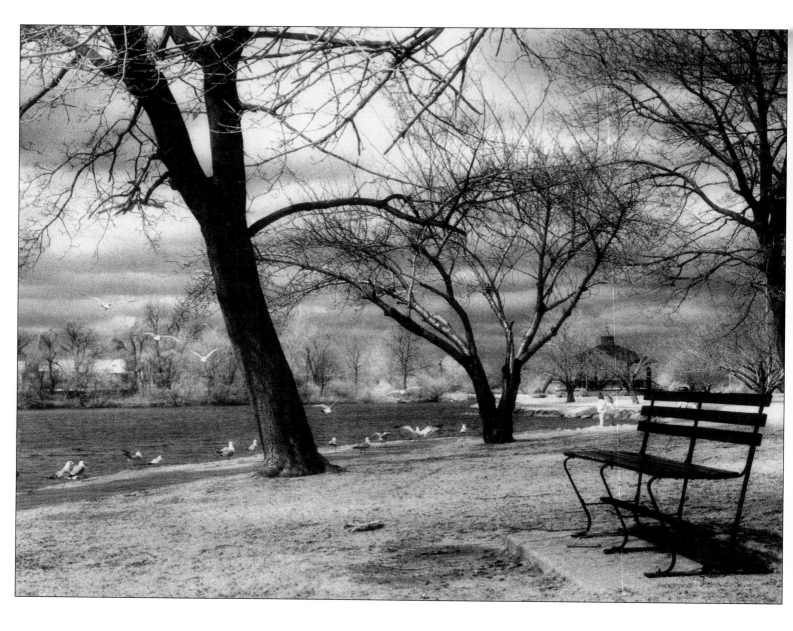

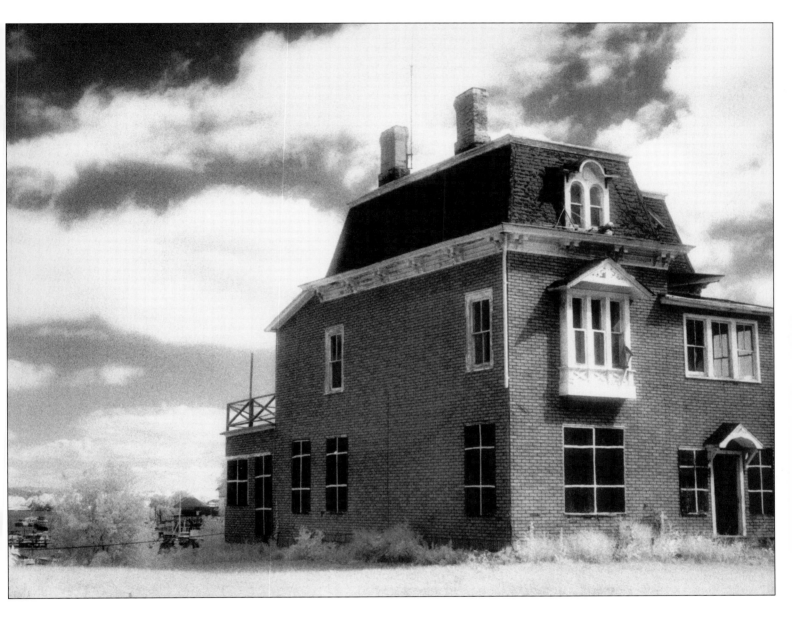

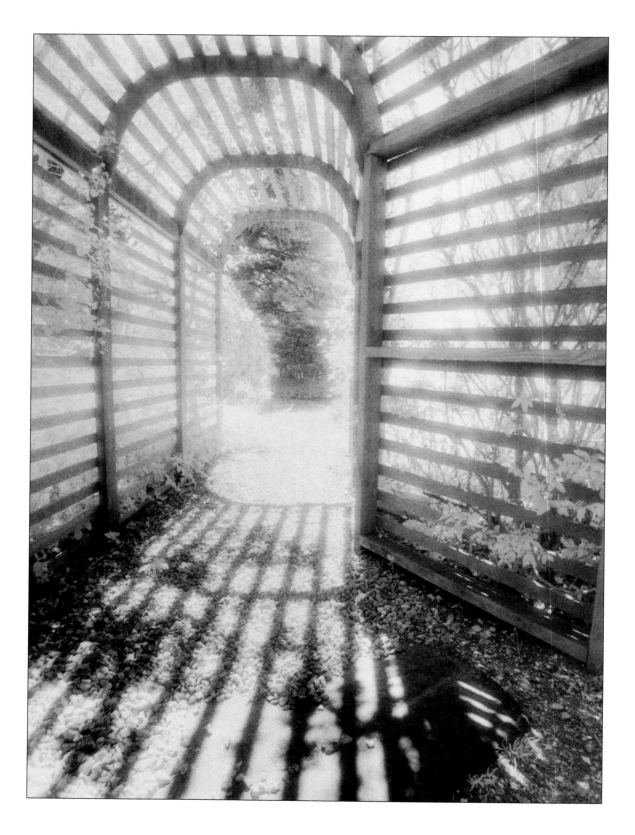

Summary

I have been photographing with infrared film for over sixteen years. In that time, I've discovered the most interesting characteristic of the film is its ability to transform even the most ordinary scene into an extraordinary photograph.

Perhaps you have photographed a scene in the past, composed it well, but were left unsatisfied with the results because the image failed to make an emotional connection.

A print made from infrared film can evoke a mood or feeling missing in the same photograph shot with conventional film.

Infrared film can provide the inspiration and excitement to make photography the enjoyable experience it should be.

Infrared photographs attract attention. Their unusual appearance and magical quality together with your imagination and choice of subject matter can trigger an emotional response from viewers.

The dreamy, evocative images of B&W infrared usually prompt people to ask questions about technique and effects. They want to know how I achieved the "grainy" appearance, the "snowy" effect, or the mystical, dream-like atmosphere.

With color infrared, people question the altered color of a scene or subject. Sometimes I share the "secret" of infrared, while other times I maintain the mystery and encourage people to appreciate the images for what they are, not how I achieved them.

These photographs are a celebration of dreams, imagination and memories captured on infrared film.

The power of light, the dramatic tones and ethereal aura of infrared photography create an altered view of that which we believe to be reality.

Notes from the Author

Cameras used to shoot the photographs for this book: Minolta X-700 and Canon AE-1.

Lenses used: Canon 28mm f/2.8, Tokina 28-70mm f/3.5-4.5, Sigma 18-35mm f/3.5-4.5 and Hoya 80-205mm f/3.8.

Filters used for B&W infrared: No. 16 orange, No. 25 red, No. 29 deep red and No. 87 infrared.

Filters used for color infrared: Polarizer, No. 12 yellow, No. 16 orange and Cokin® Varicolor filters — purple-orange, red-green and blue-yellow.

"...a celebration of dreams, imagination and memories..."

Glossary

anti-halation coating — A coating on the back of film to protect against the formation of halos (halation) around bright objects.

aperture — The lens opening through which light rays pass. The diaphragm of the lens determines the size of the aperture opening and controls the amount of light that reaches the film.

ASA — Abbreviation for American Standards Association. A system of rating the speed, or light sensitivity, of film.

bracketing — The technique of making multiple exposures of a subject by increasing or decreasing exposures from the actual meter reading. Changes are usually made by adjusting aperture or shutter speed settings.

burning-in — Increasing the amount of exposure in a given area of a print in order to darken that section of the image.

changing bag — A light-tight cloth bag with elastic arm holes used for loading and unloading infrared film, or loading any film onto a reel for tank processing.

color polarizing filter — A combination of gray and colored polarizing filters. Any color from gray to the full color of the filter can be obtained by rotating the filter frame.

contact sheet — A sheet of images of the negative strips, produced by placing the negatives in contact with photographic paper and exposing the negatives to light. Contacts are useful for many different things, including: to decide exposure information, which negatives to print, and how to print the negatives.

contrast — The difference in brightness between the darkest and lightest areas in a negative or print.

DX coding — Silver bar code pattern printed on the outside of film cassettes. When read by an in-camera sensor, the camera automatically sets the film speed and other information.

deep red filter (NO. 29) — Blocks blue and ultraviolet light. When used with B&W infrared film, can yield spectacular sky effects, cloud contrast and snowy foliage, producing dramatic images. Penetrates atmospheric haze.

density — The darkening or opaqueness of a negative produced by exposure and development.

developer — A chemical solution used to convert a latent image on exposed film or photographic paper into a visible image.

dodging — Decreasing the amount of exposure received by a part of a print to lighten that section of the image.

electromagnetic spectrum — Term used to refer to the whole range of electromagnetic radiation. Various types of radiation have different wavelengths. At one end of the spectrum are relatively short wavelengths (ultraviolet) and at the other end are the longer infrared (below red) wavelengths. Nestled in the middle is visible light (from violet to red).

emulsion — The light-sensitive coating on film or photographic paper made up of grains of silver halide.

exposure — The total amount of light that the shutter and aperture allow to reach the film. Exposure also describes the action of light on the film that

creates the latent image. In printing, exposure of the photographic paper is determined by the size of the enlarger lens aperture and the amount of time the light remains on the paper.

exposure compensation — F-stop adjustment made to increase exposure, required when using filters because they absorb light.

exposure index (EI) — A number used to indicate the effective speed of a film, established through exposure and development tests made by the photographer.

exposure latitude — The amount by which it is possible to over or under-expose a film. Least latitude occurs with low film speeds and greatest with high speeds.

f-stop — Term that indicates the size of the lens opening. The f-stop numbers are found on a ring on the lens barrel. A small f-stop number produces a large aperture and a large f-stop number produces a small aperture.

far infrared radiation — The area of the electromagnetic spectrum that produces heat, containing wavelengths from 1200 nm to 1 mm that infrared films cannot record.

fiber-based (FB) paper — A printing material that has a gelatin-supported emulsion on a paper base.

film speed — The light sensitivity of film. Fast films are more sensitive to light than slow films are. The higher the ISO/ASA number of a film, the more sensitive the film is to light.

filter factor — Number assigned to a filter to calculate the effect of the filter on exposure. It is a multiplier of the metered exposure prior to the addition of the filter.

filter and filter gel — Thin pieces of optically flat glass or hardened gelatin, colored with dyes that transmit limited portions of the photographic spectrum. In B&W photography, filters and gels absorb parts of the spectrum and make it possible for an object to appear lighter or darker than another.

fixer — A chemical solution used for film and print processing. Fixer converts unexposed and undeveloped silver halides into water-soluble salts that are rinsed away, making the image permanent.

flash fill — Flash used as a secondary light source to reduce contrast and increase shadow detail.

focal length — The distance from the optical center of a lens to the film plane when focused at infinity. The shorter the focal length of a lens, the wider picture angle. The longer the focal length, the narrower the picture angle.

fogging — Density in film emulsion caused by non-image forming light or extreme heat.

grain — The irregular clumps of silver halide crystals from which photographic emulsion is composed. Fast films have higher grain structure than slow films.

guide number — Number that indicates the power of a flash relative to the film speed (ISO/ASA) in use. The formula is: guide number = f-stop x flash-to-subject distance.

halo (halation) — The spreading of light beyond its proper boundaries. The phenomenon is characterized by a luminous halo-like band around an image, caused by highly reflected or transmitted infrared radiation.

handcoloring — Applying color (oil, acrylic, watercolor, etc.) manually to a B&W print for special photographic effects.

haze — Loss of general contrast in an image due to scattering of light by fine particles in the air.

highlight detail — Details visible in areas that are lightest in the subject. These appear as dark parts in the negative and light parts in a print.

highlights — The brightest areas of the subject, represented by the darkest areas of the negative, which reproduce as light tones on the print.

image tone — The coloration of B&W photographic paper. Image tones are usually cold, neutral or warm.

infrared digital camera — A camera that uses non-film technology to capture and gain access to high quality infrared images, stored on disk.

infrared film — Specialized photographic film coated with an emulsion that is sensitive to reflected, emitted and transmitted infrared radiation.

infrared filter — Designed for use with infrared film to allow only transmission of radiation in the near infrared region of the spectrum. There is no visible light transmission. Produces extreme sky and cloud contrast and dramatic tonal effects.

infrared focusing mark — A mark indicated on the lens barrel by either a red or white line or "R." It is the focus adjustment for B&W infrared film.

infrared radiation — Band of wavelengths beyond the red end of the visible spectrum beginning at about 700 nm to 1 mm. It is invisible to the human eye, but only the near infrared range from about 700 nm to 900 nm can be recorded by infrared film.

ISO — Abbreviation for International Standards Organization. An international system of rating the speed or light sensitivity of film. ISO is replacing the ASA system.

latent image — Invisible image formed on the negative by exposure to light that becomes visible through chemical development of the film.

light meter — An instrument that measures the amount of light reflecting from or falling on the subject.

light piping — The traveling of (infrared) light from the film leader onto the film inside the canister, which causes the film to fog or streak.

nanometer — One billionth of a meter, unit for measuring the wavelength of electromagnetic radiation.

orange filter (No. 16) — Absorbs some blue and ultraviolet light and creates cloud/sky contrast. Used with B&W infrared film yields darkened skies and white foliage and grass. With color infrared film, produces magenta grass and foliage, with natural blue skies and water.

overexposure — Occurs when too much light is received by film or paper resulting in a dark (dense) negative or light print.

panchromatic film — B&W film sensitive to all colors of the spectrum, including red.

peak (spectral) sensitivity — Maximum response of a photographic emulsion to a specific wavelength or wavelengths in the electromagnetic spectrum. This response is measured in nanometers.

polarizing filter — Filter that removes glare and unwanted reflections caused by light by absorbing much of it. Used with color infrared film, will heighten the spectacular false-color effects by improving color fidelity.

pressure plate — Smooth panel located on the inside of the camera back that holds the film in the correct plane for exposure.

pulling film — The overexposure (from film speed lower than the established speed) and underdevelopment of film to reduce the effective speed of the film.

pushing film — The underexposure (from film speed higher than the established speed) and overdevelopment of film to increase the effective speed of the film.

quartz-halogen lamp — A tungsten filament lamp that recycles vaporized tungsten back to the filament to prevent the bulb from blackening for more consistent light intensity and a constant color temperature of 3200°K.

red filter (No. 25) — Absorbs blue and ultraviolet light and creates dramatic sky effects by darkening blue skies while emphasizing the stark whiteness of clouds. Used with B&W infrared film, turns foliage and grass

white and cuts through atmospheric haze. With color infrared, will cause grass and foliage to appear orange and the sky will record as yellow/green. White objects and clouds will take on a slightly yellow hue.

reflected-light meter — A device that measures the light that reflects from the subject.

resin-coated (RC) paper — A printing material that has the emulsion and support between layers of plastic.

shadow areas — Darkest areas in a print (lightest in a negative) that correspond to parts of the original subject that were less strongly illuminated by the light source.

shadow detail — Details visible in areas that are darkest in the subject. These appear as light parts in the negative and dark parts in a print.

shutter speed — The length of time the shutter curtain of the camera remains open, allowing light in from the lens aperture to affect the film. Shutter speeds are calibrated in speeds of fractions of a second or multiples of complete seconds.

spectral sensitivity — Relative response of a photographic emulsion to the wavelengths in the electromagnetic spectrum, measured in nanometers (nm).

stop bath — A chemical solution used to stop the action of film or paper developer.

TTL dedicated flash — Autoflash unit that (when used with a camera with a TTL metering system) communicates with the camera's electronics. Incorporating a sensor inside the camera via a series of electronic pins (on the bottom of the flash unit) the sensor measures the light coming through the lens. In the program mode of the camera, TTL flash controls shutter speed and aperture.

TTL (through the lens) meter — A type of light meter that measures the light coming through the lens of the camera.

time exposure — General term for an exposure longer than the slowest shutter speed setting or in general, longer than one second.

tonal range — In photographic film and paper, shades of gray between solid black and stark white.

toning — Using chemicals to change the color or tone of a B&W print.

tungsten light — Artificial light source using a tungsten filament heated by electric current with color temperatures ranging from 2800°K to 3400°K.

ultraviolet radiation — Electro-magnetic radiation of wavelengths between approximately 10 and 400 nm, invisible to the human eye, but shorter than those of (visible) violet light. Most photographic film is sensitive to ultraviolet to some extent.

underexposure — Occurs when too little light is received by film or paper resulting in a (thin) light negative or dark print.

variable color filter — A filter that is a combination of one gray polarizing filter and two colored polarizing filters. The two dominant colors of the filter as well as intermediate colors can be obtained by rotating the filter frames.

variable contrast filter — Paper that produces a range of different contrasts on one type of paper through the use of printing filters.

washing agent — A solution used to make the washing of prints more effective, reducing washing time.

wavelength — Method of identifying particular electromagnetic radiation, considered as rays progressing in wave-like form. Wavelengths are measured in nm.

wetting agent — A solution that allows film to dry without water spots.

yellow filter (No. 12) — Absorbs blue light and increases contrast. When used with color infrared film, records grass and foliage as magenta while rendering the sky a natural blue.

Index

Other Books from Amherst Media, Inc.

Basic 35mm Photo Guide
Craig Alesse

Great for beginning photographers! Designed to teach 35mm basics step-by-step — completely illustrated. Features the latest cameras. Includes: 35mm automatic and semi-automatic cameras, camera handling, *f*-stops, shutter speeds, and more! $12.95 list, 9x8, 112p, 178 photos, order no. 1051.

Infrared Photography Handbook
Laurie White

Covers black and white infrared photography: focus, lenses, film loading, film speed rating, heat sensitivity, batch testing, paper stocks, and filters. Black & white photos illustrate how IR film reacts in portrait, landscape, and architectural photography. $24.95 list, 8½x11, 104p, 50 b&w photos, charts & diagrams, order no. 1419.

Wedding Photographer's Handbook
Robert and Sheila Hurth

The complete step-by-step guide: everything you need to start and succeed in the exciting and profitable world of wedding photography. Packed with shooting tips, equipment lists, must-get photos, business strategies, and much more! $24.95 list, 8½x11, 176p, index, b&w and color photos, diagrams, order no. 1485.

Lighting for People Photography
Stephen Crain

The complete guide to lighting and its different qualities. Includes: set-ups, equipment information, controlling strobe and natural lighting, and much more! Features diagrams, illustrations, and exercises for practicing the lighting techniques discussed in each chapter. $29.95 list, 8½x11, 112p, b&w and color photos, glossary, index, order no. 1296.

Handcoloring Photographs Step by Step
Sandra Laird & Carey Chambers

The new standard reference for handcoloring! Learn step-by-step how to use a wide variety of coloring media, such as oils, watercolors, pencils, dyes and tones, to handcolor black and white photos. Over 80 color photos illustrate how-to handcoloring techniques! $29.95 list, 8½x11, 112p, color and b&w photos, order no. 1543.

Telephoto Lens Photography
Rob Sheppard

A complete guide for telephoto lenses! This book shows you how to take great wildlife photos, portraits, sports and action shots, travel pics, and much more! Features over 100 photographic examples. $17.95 list, 8½x11, 112p, b&w and color photos, index, glossary, appendices, order no. 1606.

Wide-Angle Lens Photography
Joseph Paduano

For everyone with a wide-angle lens or people who want one! Includes taking exciting travel photos, creating wild special effects, using distortion for powerful images, and much more! Part of the Amherst Media's Photo-Imaging Series. $15.95 list, 7x10, 112p, glossary, index, appendices, b&w and color photos, order no. 1480.

Great Travel Photography
Cliff and Nancy Hollenbeck

Learn how to capture great travel photos from the Travel Photographer of the Year! Includes helpful travel and safety tips, packing and equipment checklists, and much more! Packed full of photo examples for all over the world. Part of the Amherst Media's Photo-Imaging Series. $15.95 list, 7x10, 112p, b&w and color photos, index, glossary, appendices, order no. 1494.

Big Bucks Selling Your Photography
Cliff Hollenbeck

A complete photo business package for all photographers. Includes secrets to making big bucks, starting up, getting paid the right price, and creating successful portfolios! Features setting financial, marketing and creative goals. This book helps to organize business planning, bookkeeping, and taxes. $15.95 list, 6x9, 336p, order no. 1177.

Special Effects Photography Handbook
Elinor Stecker Orel

Create magic on film with special effects! Little or no additional equipment required, use things you probably have around the house. Step-by-step instructions guide you through each effect. $29.95 list, 8½x11, 112p, 80+ color and b&w photos, index, glossary, order no. 1614.